BODY
Magic

"An entertaining and highly informative work. All of the tricks in *Body Magic* are great fun and many are truly astonishing."
—*Psychology Today*

BODY
Magic

John Fisher
illustrated by Derek Lucas

M. EVANS
Lanham • New York • Boulder • Toronto • Plymouth, UK

M. Evans
An imprint of The Rowman & Littlefield Publishing Group, Inc.
4501 Forbes Boulevard, Suite 200, Lanham, Maryland 20706
http://www.rlpgtrade.com

10 Thornbury Road, Plymouth PL6 7PP, United Kingdom

Distributed by National Book Network

Library of Congress Cataloging-in-Publication Data Available

Fisher, John, 1945—
 Body magic.
 1. Conjuring. 2. Human mechanics. I. Title.
 ISBN 13: 978-1-59077-468-7 (pbk: alk. paper)
GV 1547.F541978 793.8 78-6387

\circleddash^{TM} The paper used in this publication meets the minimum requirements of American National Standard for Information Sciences—Permanence of Paper for Printed Library Materials, ANSI/NISO Z39.48-1992.

Printed in the United States of America

For Genevieve, of course

Acknowledgments

My thanks are due to many people for the help they have given in the conception and completion of this book. It is impossible to list every single individual, but I should like to place on record my debt to the following: Edward Beal, David Berglas, Ali Bongo, Ken Brooke, Chan Canasta, Maggie Chapman, Leslie Cole, Professor E. A. Dawes, Maurice Fogel, Vivien Green, the late Robert Harbin, Peter Humphries, Ricky Jay, Paula Johnson, Peter Lane, Eric Major, Jay Marshall, Richard Simon, Paul Stone, Betty Wallace, Donald Wallace, A. H. Wesencraft and Terry Wright.

Contents

1 "Nothing up my Sleeve . . ." *page* 11
2 The Brain as Svengali 14
3 The Enigmatic Eye 26
4 An Ear for Magic 47
5 Tantalising Tastes and Mystic Smells 56
6 That Uncertain Feeling 61
7 Sleight of Hand 75
8 Tricks for the Memory 83
9 Thoughts that go Bump in the Night 92
10 The Psychic Connection 104
11 A Suggestion of Hypnosis 111
12 Blood Sport 120
13 "May the Force be with You" 126
14 Finale 148
 Bibliography 151
 Guide to Body Tricks 157

1 "Nothing Up My Sleeve..."

Look at yourself in a mirror now. The face you appear to wear is not the one you will be wearing in six months' time. In fact, no physical, tangible part of you, the brain excepted, stays the same throughout your life. Every day your chemical constituents undergo change, even your bones, the solidity of which might have led you to suppose that they were more permanent features than other parts of the anatomy. Our bodies represent a constant cycle of food ingested, dispersed into amino acids, and then converted into cell structure, which is constantly being discarded and renewed. Exchange the mirror for an old photograph of yourself and what do you see – yourself or a spooky alter-ego?

What you will certainly see is a breathtaking miracle of chance. The likelihood that each of us is who we are is something like one in 64,000,000. At conception each parent donates at random twenty-three of the forty-six chromosomes (the different structures by which genetic information is transmitted) inherent in the human cell. The number of ways you can permutate twenty-three out of forty-six is approximately 8,300,000. Combined with the similar combinations of twenty-three from the other parent, the figure leaps up to 64,000,000. Parents would have to conceive that many times again to ensure another child similar to their first in every detail.

The Wizard of Id, the craggy cartoon character created by Brant Parker and Johnny Hart, addresses his cynical monarch in total seriousness, "As you can see, there is nothing up my sleeve." "Right," grudges squat King Id, the tyrant's tyrant. "Now, if you'll watch closely," continues the Wizard, "I shall . . .", at which point his pinprick eyes catch sight of the cuff and he realises he is not the wizard he thought he was. His arm itself has gone the way of all those packs of cards, doves and flimsy handkerchiefs: "Good Lord, there *is* nothing up my sleeve!"

Nothing is closer to us than our body, nothing is taken more for granted, and consequently nothing would be expected to surprise us less. One comforting thought for an author about to pen a manuscript on the anatomy is that all his readers will be intimately acquainted with his subject. And yet, while no one will have difficulty in distinguishing the human form from any other living organism, and most will have some inkling at least of its inner mechanisms, few will appreciate the mysteries and subtleties of its intricate structure. It represents a treasure chest of secrets and surprises which – because they are removed from

the mainstream of practical medicine – have to an extent been forgotten or passed over by doctors, at the same time as they have been capitalised upon by magicians, hypnotists and vaudeville mind-readers in their quest for apparent miracles with which to entertain their audiences. The body of every one of us represents a self-contained magic show of its own – a scenario whereby we can be seen to possess a quite separate self of which we were not previously aware, which it is possible to control, condition, manipulate, either in ourselves or in friends, to produce not only the seemingly inexplicable but at the same time a new sense of awareness.

Maybe it is timely for such a book to be written. If one had to single out one trend that has hallmarked publishing in the Seventies, it would be the deluge of works purporting to investigate the occult, esoteric areas of self-awareness, and psychic manifestations of all kinds. The reason for such a boom is not difficult to understand; it is the inevitable reaction against an age straitjacketed by science, technology and the gross materialism such progress brings. While, however, the craving for escape is understandable, and the optimism that looks towards the unknown even commendable, the actual lifeline grasped at by the escapists themselves must be precarious by the very nature of its elusiveness and uncertainty. However high one may pitch one's hopes that there is more to the self than the cluster of cells the geneticists allow, sadly no one can ignore the web of callous exploitation, pomposity and deceit that has been woven around such studies from the earliest days. This is not to say that for every discredited spoon-bender, psychic surgeon and exponent of psychokinesis, there will not be six bona-fide students seriously dedicated to achieving some kind of scientific breakthrough. However, after years of painstaking research and limitless vision on the part of the latter, we are still no step nearer an acceptable scientific proof of supernatural phenomena.

Ironically, as this book progressed, it became apparent that many phenomena which fell into this category, once debated as being unaccountable in purely physical terms, such as table-tilting, water-divining and various forms of thought-reading, had a sound physiological basis. What was once thought to be the paranormal, now stood revealed as normal, fixed on fairly basic feet of clay. This is where so many psychic adherents will make a detour from the central issue, emotionally committed as they are to go off in search of new phenomena, on elusive higher planes, at all expense of reason, forgetful that if a thing, however remarkable, exists at all, it must necessarily exist in nature.

One does not wish to sound defeatist, but maybe they expect too much. Look as far out to the horizon as you can, then strive to look one yard further. You will inevitably fall short of success by that yard. Reserve that additional effort, however, to enhance your experience of

the distance between you and the horizon and you must be rewarded positively. This, if any, is the attitude this book takes of the human body. If we want that cluster of cells to amount to more than we superficially know it to be, perhaps we should look to the rational potential that can be tapped within it, rather than be swayed by the heady powers of imagination and the simple will to believe, which would have us demand the impossible and then see us fail in our credulous attempts to fit fantasy to fact.

When a book of conventional magicians' secrets is made available to the lay public, not only does uproar issue from the ranks of the prestidigitators themselves, but a disappointed thud can be heard from the direction of audience appreciation. The secrets disclosed in this book, however, being part of nature's blueprint for each single one of us, are as enthralling as the phenomena they throw into perspective. One is reminded of the words spoken by the enigmatic character Conchis in John Fowles' novel, *The Magus*: ". . . mystery has energy. It pours energy into whoever seeks the answer to it. If you disclose the solution to the mystery you are simply depriving the other seekers of an important source of energy." Here are secrets that retain their energy even in the knowing, possibly because the search for the innermost workings of the mind and body can never cease. In the way that no part of the body can be moved without somehow bringing other less obvious parts into play, so each secret is part of a larger one, culminating in the total understanding of a machine which we all possess, which can still make the most extravagant computer resemble a tinsel toy.

The book that follows does not pretend to be a profound one. Its aim is to astound and entertain as much as to instruct. Its style will disappoint those searching for technical jargon. Its author sets out with much the same premise as most of his readers: that of an average human being trying to understand. So, prepare to meet one of the world's great miracle workers. Wild, baffling, stimulating, it knows its act backwards. It pulls back its sleeves. One eye gives a teasing wink. It has only to begin. Ladies and gentlemen, abracadabra – the body – your body!

2 The Brain As Svengali

If the body is a magic show, then the brain is its director; the Orson Welles figure in a Svengali cloak, under whose spell the overall working of its miracles must inevitably come. None of the surprises detailed in these pages can be experienced without some claim being made upon its attentions; but unlike many a figure lurking behind the scenes, it can more than hold its own in the centre of the stage. A study of its mechanism reveals aspects fantastic enough to demand the spotlight on their own account.

Nothing man has ever invented can match the complexity and sophistication of this unlikely, grapefruit-shaped mass of grey and white jelly, weighing no more than three pounds, that resides in our skulls. Its versatility bespeaks a Leonardo da Vinci within each of us. Only through the medium of the brain can man reason, remember, communicate, adapt, invent, dream, interpret any one of the five senses, register pain, raise an eyebrow, anything.

Few things about the brain are more mysterious than its relationship with the mind, an entity as immaterial as the brain itself is tangible. No one has ever seen the mind, perhaps best tentatively defined as the energy of the brain, in that it would appear to use the brain and the attendant nervous system in the way that an electrical current uses an electronic circuit, and as such is the over-riding instigator of all human action. These very pulses, however, provide the vital link in the study of the way the brain itself works. Both brain and nervous system are constructed in part from special nerve cells, or neurons, which vary in shape and size. Round, spindly or oval, on average they measure not much more than a thousandth of an inch across. Although the brain by itself contains no less than 30,000 million of them, at no point does one neuron touch another. The brain works by receiving and relaying electrical signals in spark-gap fashion, backwards and forwards between itself and the millions of other neurons situated all over the body at speeds of up to 225 mph. Even when we are asleep more than fifty million such messages are being sent back and forth throughout the body every second. Only that way does the heart keep beating, the body maintain a steady temperature, and the lungs maintain their vital oxygen supply. Not that we are aware of this activity even when awake. Not the least important thing at which the brain excels is the careful selection of what it cares to draw to our attention. How else could we cope with the vast amount of information flooding in from outside? There would be little time left if we had to think consciously about every single physiological factor involved, say, in

digesting our food or in pumping blood to the right place at the right time.

Sir John Eccles, the distinguished neurophysiologist, once intuitively described the brain as "the kind of machine that a ghost could operate, if by 'ghost' we mean in the first place an 'agent' whose action has escaped detection even by the most delicate instruments". Maybe there are parallels between mind and ghost. Both certainly lay claim to invisibility to the human eye. Consequently, it intrigues people to learn that it is possible to see the brain itself in action. That is the purpose of our first test.

Body Trick 1

The French poet Guillaume de Salluste once described the eyes as "windows of the soul". Maybe he had special knowledge of the nature of this experiment. Anatomically the eyes are an extension of the brain, almost as if part of it were on display for psychologists to study.

Buttonhole a friend whom you know well enough for him not to be disconcerted when you peer into his eyes. Then in your own mind decide upon a seven-digit number. Tell your friend that he must memorise that number when you call it out and then recite it back to you after ten seconds. All this time you must watch his pupils. If your friend is normal, you will see them dilate as you tell him the number, contract during the pause, then dilate again as he repeats the number. The experiment demonstrates how brain and pupils interact when the brain is engaged in mental activity like memorising or recalling information.

Pupil size also provides an uncanny outward manifestation of inner emotion. The pioneer of this area of research, the psychologist Eckhard H. Hess, has described a test he performed with eight picture postcards, all unexceptional landscapes with the exception of a semi-nude pin-up. Having shuffled the cards in such a way that he did not know their order, he held them above his head and showed them one at a time to his assistant. He looked for a noticeable increase in the size of the latter's pupils. When it came, on the seventh card, he knew he must be holding the pin-up.

The size of the pupil is principally determined by the degree of light intensity – glaring sunlight will reduce it to the size of a pin-head – and the distance of the object viewed. That it can, however, also be affected by both emotional states and intellectual activity would appear to have been known for a long time by Chinese jade dealers, trained as they are to watch a customer's eyes to learn when he is impressed by an objet d'art and consequently more likely to pay a high price. There is no reason why a magician dealing through a pack cannot identify the card a

spectator is concentrating upon by watching his pupils dilate when his correct card is turned up. Hess's studies, however, have gone to sophisticated lengths to show how remarkably sensitive a barometer of certain mental activities the pupils can be. Men's pupils dilated more at the sight of a female pin-up than vice versa. To compensate, women registered more positively when confronted with a picture of a baby in its mother's arms. The procedure also worked in reverse, as an indicator of negative response in the context of unpleasant material, pupils contracting drastically in women when shown pictures of sharks, in both sexes when shown pictures of a crippled child. Other tests have revealed how we automatically respond to these changes in other people without being fully conscious of the reason. Male subjects were shown two

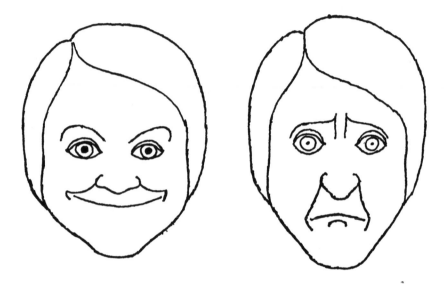

apparently identical pictures of the same girl and asked to say which they found more appealing. In each case one photograph was voted "more feminine", "prettier", "softer" than the other, yet they could not say why. Then they were shown how the pupils in the photograph of their choice had been retouched to make them extra large. Needless to say, their own pupils showed an increased dilation when confronted by the same. As far back as the Middle Ages women impregnated their eyes with belladonna, a drug which dilates pupils artificially. They must have known then that large pupils are attractive to men; indeed the word "belladonna" is Italian for "beautiful woman". One can only guess that large pupils in a woman signify at an intuitive, non-verbal level a very special interest in the man in attendance on her.

This unconscious interpretation of pupil size was demonstrated in another test in which drawings of pairs of faces, about three-quarters

the size of an average adult face, but without pupils, were given to subjects who had to sketch in the size of pupil which they thought most suited the face. The pair of faces resembled the classic masks of comedy and tragedy, one smiling, the other scowling.

When the results were tabulated, it was found that fifteen out of twenty subjects drew larger pupils on the grinning face than on the groaning one. When the same test, however, was repeated with younger people between the ages of nine and fifteen, it was found that they tended to draw pupils of about the same size on both faces, which suggests that the turning point for unconsciously attributing different meanings to pupils of different sizes does not come until mid-teenage.

Body Trick 2

From a test that shows the brain at work, to one that provides a special understanding of the speed at which it works. You will need a crisp, flat, unwrinkled treasury note. Hold it at one end with its length pointing downward between the middle finger and thumb of your right hand (if you are right-handed). Next, poise your left index finger and thumb

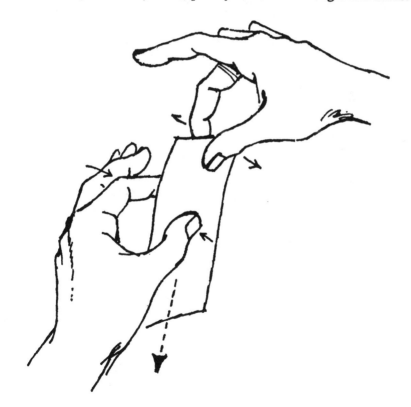

on either side of the note at its centre, as close as you can get to the note without actually touching it. If you now release the note, you will quite easily catch it in the left hand before it falls to the floor, even though — and this is important — you must not move any part of the left hand until the right has let go of the note.

Try this on yourself a few times before conscripting the services of someone to participate with you. Then hold the note as before, and instruct him to position his own finger and thumb on either side of the note as you did, ready for the catching. You stress, though, that he must not make to grab until you release the note, which you must do suddenly, without giving any advance warning whereby he can anticipate your actions. Again you drop it, but what you found to be the easiest of tasks, he finds impossible. His fingers close on thin air.

The reason you succeed while your friend fails is because your brain is able to send the electrical impulse signifying "let go" to the right hand at exactly the same moment as it sends the one signifying "catch" to the left. Consequently you have no difficulty in timing the catch to follow a split second after the release. Consider, however, what happens when someone else attempts to catch the money. An electrical impulse has to be sent from his eyes as they register the release to his brain where it passes into consciousness, before his brain itself can transmit its own "catch" signal to his fingers. The note escapes in that merest fraction of a second before his brain can reverse its order to the hand.

Body Trick 3

Close your eyes and try to assess each side of your body separately. First introduce your mind to your right side, to the total exclusion of your left. Feel it from within you. Weigh it. Try to assess its strengths, its weaknesses, its flexibility, its rigidity. Take your time. Then carry out exactly the same procedure with your left side. When you have completed the process, consider the following questions, closing your eyes each time to tune back into your left and right feelings before you give your final answer:

1. *Which side of you is more feminine?*
2. *Which side of you is more masculine?*
3. *Which side is more active?*
4. *Which side is more passive?*
5. *Which side is more logical?*
6. *Which side is more intuitive?*
7. *Which side is more artistic?*
8. *Which side is more mysterious?*

If you are right-handed, you will almost certainly have answered "right" to the second, third and fifth questions, "left" to the rest!

None of us need telling that we have two eyes, two lungs, two kidneys. It is less obvious that the brain itself is a similarly paired structure, comprising two hemispheres linked by a large bundle of nerve fibres known as the corpus callosum. To resume the electrical analogy, the hemispheres could be described as crosswired in that each controls the opposite side of the body. The neurons on the left side control much of the activity on the right side of the body, and vice versa. Consequently with right-handed people, the left hemisphere is dominant; with left-handed, the right. Since nineteen out of every twenty people are right-handed, and studies on patients with brain damage have demonstrated that the left hemisphere is mainly responsible for speech, it is not surprising that the left hemisphere has long been regarded as dominant in controlling human actions.

Recent studies have proved that while the left hemisphere governs our ability to talk, to write, to tackle analytical problems involving logic and mathematics, the right should not be discounted, controlling as it does our potential for spatial judgment, creativity and appreciation of music and art. For this reason you seldom meet both Gilbert and Sullivan combined in the one person. By concentrating on people whose corpora callosa had been surgically cut to alleviate epilepsy, the psychologist Roger Sperry discovered that one could behave perfectly normally in this condition, with one exception, namely that one's right hand would literally not know what the left hand was doing. One test involved a patient holding a pencil out of sight in his right hand. His left hemisphere enabled him to describe it verbally without difficulty. When, however, he held it in his left hand, he could not describe it at all. The right hemisphere, linked with the left hand, possesses hardly any capacity for speech. When the patient was given a choice of objects and asked to select by feeling with his left hand the one he held at the beginning of the experiment, he was able, thanks to spatial judgment, to choose the pencil, although he still could not describe just what he was doing.

David Galin and Robert Ornstein have extended such studies to normal people, by measuring the respective brainwaves from both hemispheres as the subjects go about specific tasks. Analytical tasks, such as writing a letter, revealed electrical traces of positive mental activity within the left hemisphere and a total relaxation pattern in its counterpart. Intuitive tests, like matching coloured blocks to patterns, produced results that were the exact opposite. Not that you need expensive laboratory apparatus to carry out such a test. Ask a friend a question like, "Divide 133 by 7, and subtract 12 from the result", and he will most likely shift his gaze to the right (the side controlled by the left hemisphere) as he works out the problem. On the other hand, ask a

question which relies not on analytical thought, but on spatial judgment, such as "Which way does a head look on a coin?" and he is more likely to move his eyes in the other direction.

Marcel Kinsbourne of Duke University, who noted the above phenomenon with Ornstein and others, has also devised a more physical test that makes use of a dowel-rod. Balance the dowel on the tip of the outstretched index finger of each hand in turn. With most people the dominant hand, namely the right, will prove more adept at balancing. Then repeat the process, speaking as you balance the dowel. It now becomes far more difficult to balance the rod on the right index finger, while seemingly easier to do so on the left. This is because when the left hemisphere engages in speech, its simultaneous control of the right hand is impaired. It has too much to think about. Balancing the rod on the left index finger, however, becomes easier with simultaneous speech. While you are silent, there is nothing to prevent the left hemisphere intruding upon the performance of the left index finger. However, engage the left hemisphere in speech and it is less likely to interfere with the left hand, improving the balancing potential of the latter in the process.

There is a danger that the rigid day-to-day insistence within our education on left-hemisphere functions—the reading, writing, arithmetic syndrome—may seriously undermine the potential within our right hemispheres. We need to be able to do all those three things, but not at the expense of damaging our capacity for imagination, intuition, fantasy, and, as Ornstein convincingly suggests, parasensory phenomena like telepathy and clairvoyance. A balance has to be struck. It is not enough to regard the right hemisphere appreciations such as music, art, dance and even play as mere diversions from the serious work of the three Rs. One of the leading pioneers in kicking over the linear traces of left hemispheric dominance is educationalist Edward De Bono, who coined the phrase "lateral thinking" to describe an approach to problem solving which, in its deliberate open-mindedness and facility for standing hackneyed concepts on their head, pays as much heed to the right hemisphere as to the left. First, however, let us examine for our own diversion various ways in which we can be misled by too great a reliance on the rational, logical approach and the dangers of getting stuck in the wrong context as a result.

Body Trick 4

Invite a friend to participate in a spelling bee in reverse. You spell out a word after which he is to pronounce it: "MAC DONALD . . . MAC HENRY . . . MAC MAHON . . . MAC HINERY . . ." Few people are not trapped by expectation into pronouncing that last word as some

fictitious Scottish surname, MacHinery, as distinct, that is, from machinery.

In similar fashion read out the following numbers, asking your friend to recite out loud the next higher number in sequence before you read out the following one. For example, when you announce "sixty-one", he must respond "sixty-two". "29 . . . 72 . . . 372 . . . 2,623 . . . 4,099 . . ." You will be surprised how often people will top the sequence with 5,000 and not the correct answer which is 4,100.

Find a party where the guests will allow themselves to be divided into two equal groups. Give each member of the first group three cards on each of which is printed one anagram in order as follows: BAT, LEMON, CINERAMA. Likewise give the second group three cards bearing the following words: WHIRL, SLAPSTICK, CINERAMA. The cards are in envelopes ordered in such a way that either BAT or WHIRL will be withdrawn first, CINERAMA last. Instruct the members of both groups to withdraw their first card, explain that it represents an anagram of another word and that they must raise their hands as soon as they can solve it. You will, of course, get much response from the BAT (TAB) side, none from the other. Progress to the second card. The instructions are the same. Again those with LEMON (MELON) will score heavily, those with SLAPSTICK negatively. Finally, let them take out the third anagram. Although they all now possess the same word, CINERAMA (AMERICAN), the "Bat and Lemon" group will display a far greater show of hands than the "Whirl and Slapstick" side. In actual fact, both WHIRL and SLAPSTICK are impossible anagrams. Naturally those given them couldn't solve the problem. Having failed twice, those with non-anagrams get stuck in a groove where failure is virtually preconditioned, even though seconds before the test began, they might have solved the third puzzle with little difficulty. This is the same kind of conditioning in which a child can find himself trapped at school, when discouraged from furthering any success he may have shown in supposedly more wayward right hemisphere oriented areas like illogic and fantasy.

When presenting prediction tricks, stage magicians have long capitalised upon the direct availability of a habitual mode of response which makes it all the harder for a spectator to break with custom. Quickly name out loud a piece of furniture, a colour, a flower, a wild animal, a digit between three and ten, a two-digit number between ten and fifty in which both digits are odd and not alike, and finally another two-digit number between fifty and a hundred in which both digits are even and not alike. You are most likely to have called out, "Chair, red, rose, lion, seven, thirty-seven, and sixty-eight." Ask someone to draw a simple geometrical figure with another separate geometrical figure inside it. The odds are strongly in favour of your receiving a triangle with a circle inscribed within it. In March 1951, the magic magazine,

Phoenix, divulged the results of tests carried out by Professor Sherman Ross and D. M. Kohl at Bucknell University. If the digits, one to nine, are arranged at random in the form of a cross, the one at the intersection will be chosen most frequently. If arranged in a triangle, the digit at the apex will score; in a circle, the one to the left of the top number. If set out in a vertical line, the fourth from the top will be selected most often, while, in a horizontal line—and perhaps most surprisingly—the very first number. Occasionally you will be off the mark, but remember that so-called mindreaders usually reserve this kind of material for large audiences, where the percentage of spectators choosing the predetermined item will border on the sensational. Part of the secret is to goad them into fast action, so fast that there is no time for second thoughts.

Fixation of this kind is more than a major hindrance to the brain with a problem to solve. The fact that the mind can be so easily manipulated along an almost predetermined line of thought accounts for the unscrupulous success of so many conmen, salesmen, copywriters and politicians—not to mention magicians—all of whom would have to look for work elsewhere should the pendulum of cerebral activity swing too far in the opposite direction. However, as people like De Bono have shown, obtaining the insight necessary to counteract such hazards is a skill which it is easier to cultivate than might be supposed.

Body Trick 5

A problem in mental arithmetic: if 111 players enter a tennis tournament, how many matches must there be to find a winner?

A man enters the lift in his office building every morning, proceeds to the tenth floor, then continues to climb by stairs to his office on the fifteenth. At the end of the day, he enters the lift on the fifteenth floor and descends to ground level. Why does he follow this strange routine?

One morning, exactly at sunrise, a monk began to climb a narrow mountain path. He continues his climb at varying rates of speed throughout the day, never straying from the path, and arriving at his destination, the temple at the summit, just on sunset. The following day, at sunrise again, he begins his descent along the same path. This time he is able to proceed with downhill ease at a faster average speed, reaching the foot of the mountain before the sun has had a chance to set. Prove that there is one spot somewhere along the path that the monk will occupy at *exactly* the same time of day on the two journeys.

Lateral thinking is a concept one should call to the rescue on those

many occasions when the more obvious logical line of approach proves to be a wild goose chase. It says that a better idea may come from an unlikely one, an erroneous one, even one that is just plain stupid. It is a way of looking spatially around, above or underneath a problem that refuses to yield to linear, analytical attack. As such it is best demonstrated when seen in action, providing the sudden shift of approach needed to solve tricky problems like those above. In the first, most people are preconditioned to expect a need for complicated mathematical calculation. They have seen those intricate family-tree-type patterns that decorate tennis club notice boards. The importance of the figure two in pairing players provides another fixation. They tend, in short, to become confused. Start at the end of the problem, though, and it becomes clearer. There must eventually be one winner. Everyone else must lose. Therefore there must be one hundred and ten matches, each of which will provide one loser.

In the same way, shift your attention from what you know the man in the lift does (most people suggest that either he is a keep-fit fanatic or he is avoiding someone he might meet in the lift at a higher level) to what he is and is not capable of doing and you will arrive at the correct answer more quickly, namely that he is a dwarf unable to reach higher than the tenth-floor button of the lift. Again, instead of imagining one monk making the two journeys over two consecutive days, suppose that two monks make them on the same day. And then, of course, what seemed murky becomes crystal clear. They *must* meet at some time on that path, provided that one begins at the summit, the other at ground level, and that they both keep to the same route.

How can one achieve this sort of success with problems that present themselves away from books with solutions conveniently provided on some other page? The answer is not by entirely discounting the logical, or what could be called vertical thinking approach. A harmony must be achieved. De Bono himself likens lateral thinking to the reverse gear on a car. Vertical thinking is the forward gears. Of course you can get by without the former, until . . .! Obviously practice is necessary. Never accept the obvious way of looking at something. Always try to find another way, to click into another context.

There is an easy, almost magical way to test the discipline for yourself. First define your problem. Then take down a dictionary. Open it at any page, and at random — blindfolded, with a pin, if you choose — pick out any word. However remote from the problem that word might first appear to be, it will in fact always throw some light on it, show some direct relevance to whatever one has in mind. The mind and not the word itself will always create that relevance. The word must of course be chosen at random, for if it is selected with any degree of consideration, then it will only be one further extension of the vertical pattern which you are trying to escape, not reinforce. On one radio programme

in which De Bono demonstrated his ideas, the problem posed was, "What shall we do about the Prime Minister?" The word chanced upon was "mushroom". It was an easy step to the idea that he might function best when kept in the dark and fed on rubbish. The results are not often as amusing as that, and will not always produce a solution as such, but always the random stimulus from without will ensure the re-structuring of established patterns of thought essential as a stepping stone to other ideas, which could themselves prove valid as solutions.

Body Trick 6

No one knows why ninety-five per cent of the world's population possesses such a firmly embedded tendency to favour the right hand. With the left hemisphere of the brain in control of the right side of the body and, as we have seen, almost always dominant because of the importance placed by society upon the functions it is responsible for, one might presume this was the explanation. Left-handers, however, give the lie to such an easy solution because they themselves are so inconsistent. While some do have reversed specialisation of the hemispheres or reveal a mixed specialisation that allows, say, both sides to be responsible for language, others refuse to differ from right-handers in that they, too, have a dominant left hemisphere.

The question of why young children experience difficulty in learning to tell left from right is equally fascinating. Observation of babies has shown that each hemisphere initially possesses the potential for both the analytical, language-oriented faculty and the intuitive, aesthetic one. Brain damage to the left hemisphere in a child up to six months old often, in fact, results in language skills developing in the right side later in life. Maybe this early flexibility provides a clue to any later difficulty we experience in being able to discriminate left from right. This suggests a potential in us all for ambidexterity both cerebrally and manually which social pressures and the need to conform have done nothing to encourage.

That we all, to some extent, preserve within us a symmetrical alter ego, in spite of our outward asymmetrical conventions and training, is shown by the following experiment. In 1937 Samuel Torrey Orton of Columbia University, in an attempt to explain the mirror-image pitfalls which jeopardise children when reading and writing, suggested that the physical memory "traces", namely the "writing" produced by external stimuli on the brain to which we refer when we wish to remember, have a tendency to become symmetrical, so that no trace of a visual pattern is established in one hemisphere without its mirror image being sub-consciously registered within the other. Certainly there do exist in both hemispheres various mirror image points actually connected by the

tissue or commissures that join the two halves of the brain. A kind of cerebral mirror is not too hard to imagine. This would explain why we tend to recognise people as easily from portraits which are in fact mirror images of themselves and seldom notice any discrepancy in the process. Orton himself found that some children, who had been exposed only to normal words, were able to read their mirror-image counterparts without difficulty.

It might surprise you to know that if you are right-handed you could well find it easier to write with your left hand (or vice versa) in mirror image than in normal script. Similarly, if you allow your left hand to act alongside the right it will execute the same movements as those of the right hand, but in mirror image. In this way you can write or draw simultaneously with both. The symmetry of butterflies and insects lends itself remarkably well to such a test, each hand responsible for drawing one side of the creature. Or you can draw a profile and its accurate reflection in a mirror simultaneously side by side. When

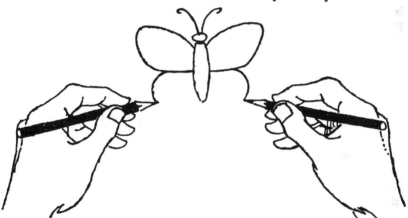

writing, there is a greater tendency to think about what is actually happening and this should be avoided. The secret is simply to forge ahead and do it. It happens automatically.

It is even possible to write in reverse fashion with your dominant hand. If you hold a postcard to your forehead and write something on the outer side from your left to right, all the time imagining that you are following your normal pattern of writing, you will again produce mirror writing. Again, the movement must be instinctive. The moment you hestitate or begin to reflect about detail such as the forward or backward direction of letters, you will fail. In an area fraught with such confusion, it is not surprising that children so often have trouble discriminating between the letters b and d or p and q, the ghost of the mirror image lingering stealthily in the background and ready at any moment to intrude upon and upset the asymmetrical performance we impose on ourselves.

3 The Enigmatic Eye

Perhaps the most amazing thing we can learn about our eyes is that we do not see with them. At least, not quite. In peering at the world through those two peepholes situated on each side of our nose, we tend to disregard the fact that our eyes—and our other senses in their turn—are very much the servants of the brain. Our vision is a process constructed within the latter and what we eventually "see" is determined by the various processing systems situated within it. We see only what our mind wants us to see.

What happens when we see? Information in the form of light waves is projected from the external world via the gap in the iris which we call the pupil, on to a highly sensitive screen called the retina, a layer of cells extending over virtually the whole of the inside of the eye. These cells translate the light stimuli focused upon them into nervous impulses and, by means of the optic nerve, transmit them to the brain for interpretation. Only then can the "seeing" really begin, and concepts such as colour, movement, space and shape take on real meaning.

Situated at the rear of the skull is an area known as the occipital lobes. This is the section of the brain which registers sight. A critical blow on the back of the head can produce blindness, even though the eyes themselves remain intact. Here resides the key to the sensation of sight. You do not even need your eyes open to experience it. In our magical mystery tour around the optical system, it would seem logical to begin here.

Body Trick 7

If you have ever "seen stars" as a result of a punch in the eye, your own visual system has been tricked. The sensation shows that you do not need light in order to trigger the retina and so produce sight.

Close your eyes and for a short while gently press the tip of your finger outward against the eyeball between the inner corner of the eye and the nose, in which position it will be just over the rim of the retina. Your field of vision should eventually experience a dark disc surrounded by a phosphorescent glow, once described ambitiously by Sir Isaac Newton as "a circle of colours like those in the feather of a peacock's tail", but more likely to prove plain yellow or amber orange.

There is no need to activate any part of the eye as such to produce this effect. Brain specialists have shown how it is possible to attach electrodes to the back of the skull adjacent to the occipital lobes and, by means of a painless electrical current, stimulate your vision – by the back door as it were – in such a way that you see your own personal psychedelic light show. Such a description, in fact, is not too much of an exaggeration since at one time in the eighteenth century it was the height of fashion to hold phosphene (the technical term for the phenomenon) parties in which even Benjamin Franklin once participated. The guests would sit round in a circle holding hands and succumb to the appropriately-aimed shocks of a high-voltage electrostatic generator. More constructively, recent research has placed in the artificial stimulus of phosphenes the hope that blind people may one day be provided with artificial vision through the sophisticated reconstruction of the external world by such displays.

Body Trick 8

Of all the parts that make up the eye the retina will claim the greatest attention. Few people are aware, for example, that it is possible actually to see its image in space. Close your left eye and hold a lighted candle below and to the right of the right eye. The head should be held slightly downward, while the eye stares upward at an angle of about forty-five degrees, though experimentation will usually be required to find the exact position. Gently move the candle around and, if you are patient, you should eventually see a grey or red background upon which the intricate blood vessels that nourish the nerve cells of the retina will appear to be magnified, traced eerily like the branches of a tree against the winter sky. To ensure the greatest chance of success, there should be no other light in the room than the candle, which must be kept moving the whole time.

Body Trick 9

Focus intently on the image of the retina obtained in the previous test and you will see that the blood vessels all converge at one place. This is the centre of the optic nerve, an area known as the "blind spot" because at this point the retina itself is devoid of visually receptive cells. We all possess two such spots, measuring about one-sixteenth of an inch in diameter, and it is a teasing challenge to prove the phenomenon for yourself.

Print your first and last initials about three to four inches apart on a postcard, one about an eighth of an inch high, the other four

times that size. Bring the card close to the face so that one eye is directly opposite each letter, then close the eye that happens to be opposite the smaller initial. Now look with the other eye at this letter and you will discover that, if the card is gradually moved backwards and forwards, at a certain distance the larger letter, in spite of its greater size, will disappear completely. This is because the light reflected from it falls upon the blind spot. The surprising thing is not that this gap in our perception is ever present, but that we never notice its existence. It was, in fact, only discovered in 1668 by the famous physicist Mariotte at the court of Louis XIV. He would seat two courtiers about two yards apart face to face and then ask them to look with one eye closed at a spot placed somewhat to the side. Each then saw his counterpart in a headless condition, a chilling reminder of the power of the guillotine in a less merciful age.

One does not immediately notice this lapse of vision in normal life. When both eyes are open, each compensates for the deficiency in the other. When one eye is closed, as here, the brain, as if to compensate for the hole in our sight, tends to fill it in with information already supplied by the eye. The latter, being constantly on the move, intermittently transmits the whole field of vision and we never notice

that at any one moment a small area is no longer there. Similarly, when the eye becomes still, as in the letter test above, it is conditioned to fill the hole with the same expanse of cardboard that we would expect to see around it.

Body Trick 10

The ability of the retina to retain on its surface an image for a little less than a tenth of a second after the real life counterpart to that image has been withdrawn, is responsible for a variety of so-called optical illusions. To demonstrate this, take two coins of similar value and rub them briskly against each other between the fingers and thumb of one hand. Viewed from above or edge on, a third penny will mysteriously appear between the other two, the result of just such a retention on the retina of the images of the coins in one position, at the same time as they are seen in another.

The duration of impressions on the retina is the principle upon which cinematography, as well as a whole nursery of optical toys, is based. The simplest of the latter is the thaumatrope, a cardboard disc depicting, say, a cage on one side and a bird on the other. It is important that they are upside down in relation to each other. When twirled rapidly on two short pieces of string attached to opposite sides of the disc, you will actually see the bird within the cage, because the picture of the cage remains fixed on the retina long enough for the picture of the bird to reappear and for them both to be superimposed as a result. In a similar fashion, one perceives movement in the separate still frames of a cinematic film as they are flashed past at certain optimal

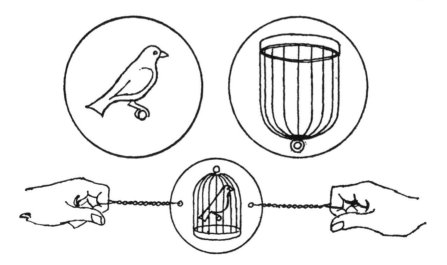

rates, each image retained on the retina from the frame before merging in our consciousness with the next.

As striking and sophisticated, though more puzzling, is another illusion of movement outlined in 1912 by the Gestalt psychologist, Max Wertheimer. If two bright lights are flashed on and off in sequence against a dark background at a distance apart of approximately six times their own diameter, it is possible to see a single point of light moving from the position of the first, across to that of the second.

It is essential, however, that the time interval between flashes be worked out and controlled with meticulous care. The "on" time for each light should be about 0·05 second; the time between the turning off of one light and the subsequent switching on of the next should be modulated between about 0·025 and 0·4 second. Should the interval be shorter, there is a danger that the two lights will appear to be on simultaneously (another illusion); longer, that you will see the lights go on and off alternately (which is what is happening anyhow). With the time scale suggested, you will initially see the first light move out towards the right and disappear, whereupon the second will appear a short distance to the left of its actual location and move back to it. Gradually increase the time interval between flashes and the apparent smooth, continuous progress of the light all the way from the first source of light to the second will be observed.

The technical term for this effect is the "phi phenomenon". Its most likely explanation is to be found in the suggestion that in certain instances, when gaps occur in the stimulation pattern of a moving object on the light-sensitive cells of the retina, the intermittent stimuli that are received are sufficient to trigger off the total movement. The retina would, in fact, appear to allow a degree of tolerance and flexibility.

Body Trick 11

Stare at an object for a considerable length of time and the retina will become fatigued to the extent that when you look away, your vision will carry before you an after-image of that object. The brighter the object, the more vivid the after-image will appear. Everyone has experienced this effect with the sun.

This process is of immense value in demonstrating the potential for ambiguity that exists in the field of retinal impressions. It surprises people to learn that after-images, far from being fixed, could be said to have a life of their own after they have been separated from source. Gaze at the cross below long enough to produce its after-image upon the retina and then project it upon a blank wall ahead of you.

You will see a straightforward right-angled cross. Now look up

and to the left. The bars of the cross will appear to close upon each other scissors fashion. Look across, up and to the right, and you will see the same effect in mirror image. Stare at a circle in the same way and by a similar process you should observe two lopsided ellipses.

Not that it is necessary to move the eyes to distort the shape of the after-image. Try projecting the after-image of the right-angled cross straight ahead, on to a wall or screen which has been drawn in perspective within a picture, and the shape will appear oblique.

This phenomenon is a natural extension of the drawing of a cube in which the right-angles on its sides appear oblique, and vice versa, as a result of perspective.

Body Trick 12

The image of the outside world which falls upon the retina is actually inverted camera-wise, before the mind, in its own mysterious fashion turns it right way up again. This can be demonstrated by the following test, in which the retina is prevented from receiving its normal inverted picture.

With a sharp pin make a hole in a piece of card or opaque paper and then hold the opening at eye level against a bright background, about six or eight inches from one eye. With the other eye closed, focus your gaze through the hole while your other hand holds the pin

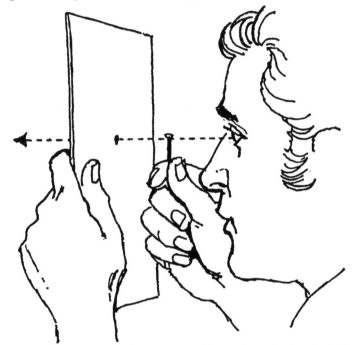

vertically between the card and yourself, so that the head of the pin is on a line level with the pinhole and your eye. You may have to adjust the position of the pin slightly but eventually you should see a shadowy image of the pin within the bright circumference of the pinhole. Surprisingly, the pin, although held upright, will appear upside down.

You have contrived a situation whereby the head of the pin is forced to cast an upright shadow on the retina, on account of the fact that the lens of the eye is unable to bring to a point the light rays that diverge so widely after passing through the tiny hole. Not illogically the brain, accustomed to correcting the normally upside-down picture in the eye right-side-up, on this occasion takes the right-side-up reflection and turns it upside-down.

Body Trick 13

One of the most intriguing functions of the brain in interpreting the pattern of light waves projected on to the retina is the adjustment it makes with regard to size. The retinal image diminishes by half each time the distance from the eye of the object viewed is doubled. That of a man ten feet away is twice as large (0·4 inches) as that of a man twenty feet in the distance. And yet both appear more or less the same size. Moreover, as the farther of the two approaches, in no way does he appear to double in stature. This is because the brain, anxious to forestall the disconcerting effects that would be produced on the field of vision if objects were seen to be changing size all the time, "corrects" the information for us and stabilises the man in our imagination at a consistent size which we regard as natural. Look, for example, at your face in a bathroom mirror. It appears its natural size. Now let the mirror steam up and with your forefinger trace round the outline of your head. You will be surprised when you measure the oval you have produced. Divested of the meaning given it by your face, it proves no larger than a grapefruit.

Richard Gregory, the psychologist who has revolutionised research into optical illusions, has suggested that many famous examples may derive from the way we are conditioned to see things the "right"

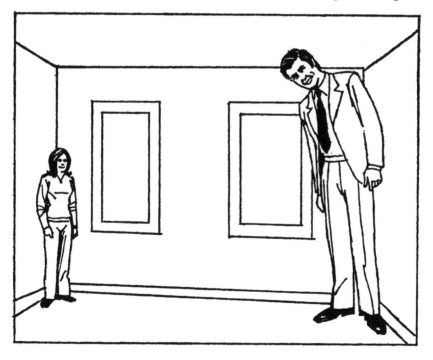

size. Nothing is more misleading in this context than the distorted room effect devised by Adelbert Ames, whereby two men, both the same size, standing at opposite corners of the room, can be made to appear like a dwarf and a giant respectively. This happens because while at face value, when viewed with one eye through a peephole at a certain point, the room appears to be normal in a rectilinear sense, in fact its back wall not only becomes progressively deeper from one end to the other, but at the nearer end the distance between

Overhead cross section

Front view

floor and ceiling is shallower, caused by the floor and ceiling themselves sloping away from the right-angle. Experiments carried out with this device, however, have revealed that some married partners, particularly newlyweds, as aware of their spouses' real size as we are aware of the actual size of our face, do not see the illusion when their other halves participate. While strangers will appear to grow and shrink as they walk about the room, husbands or wives often undergo little or no change in size in the eyes of their partners, who now choose to see the distortion of the room instead. This illustrates the extremes to which our potential for unconscious correction of size-changes can be taken. Few illusions are more seductive, more guaranteed to deceive than the Ames room; nothing, however, is more likely to destroy this particular illusion than the emotional feeling of one person for another.

Body Trick 14

In the whole landscape there can be few illusions more striking than

that whereby the full moon appears to increase as much as 2·5 to 3·5 times in size the nearer it is to the horizon, whether rising or setting. This apparent change in size has often been attributed to the density of the atmosphere through which we happen to be viewing the moon at any given time. The nearer it is to the horizon, so the air through which we observe it is that much denser and has the effect of magnifying its size. Likewise, the higher the moon in the sky, the rarer the atmosphere through which the eye has to travel, which has the effect of apparently diminishing its size. Any difference in apparent size due to atmospheric conditions, however, amounts to no more than one and a half per cent of the vertical diameter of the moon, a difference so slight as to be hardly discernible to the naked eye. Consequently, the theory that the atmosphere is solely responsible for the increase we are discussing holds no greater weight than the theory put forward by one of the philosophical cavemen in John Hart's comic strip, "B.C.", as he watches the sun swell as it sinks behind the mountains: "Look at all the daylight it has to suck up."

The reason why the moon appears to change in size so drastically is in the eye and brain rather than the atmosphere. One can easily check that the discrepancy in size is an illusion. With arms held out straight, measure the diameter of the moon with a piece of taut string both at the horizon and later at its zenith. The measurement does not change, and yet the illusion persists simply because the brain has become conditioned to expect the moon on the horizon to behave as if it were on earth. At its zenith it is easy to believe that the moon is all of 238,000 miles away. However, put it against the trees, chimneys and rooftops and it is difficult not to believe that it is there amongst them. Subconsciously we argue that it cannot now be 238,000 miles away, must in fact be much closer. In these circumstances the brain concludes that the moon should appear much larger and, led astray by details of scenery and perspective, scales its size accordingly so that it appears more or less "correct" in the new context.

Body Trick 15

One fascinating area of optical illusions exploits the brain's capacity to create alternative worlds from the same retinal image, as a result of which it is often possible to make the farther part of an object appear nearer and the nearer part farther. Perhaps the most famous example is the "Necker cube", named after the Swiss naturalist who drew attention to the effect in 1832. Study the illustration and you will see that the perspective of the cube changes depending upon which corner, X or Y, you regard as closer to you. The eye provides two sets of perspectives and the brain is able to slip from one to the

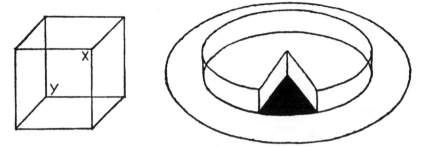

other spontaneously. Neither way is more obvious than the other, which is not the case with the cake slice illusion that follows.

Look at the plate and you will see a cake with one slice cut out. Then turn the page upside-down and observe the plate again. This time you will see the missing slice all by itself. The missing piece seems to solidify as you view it from another angle.

You see the two phenomena in this order because the brain will always choose to interpret the retinal image in the more obvious way — if there is a more obvious way. It *is* possible to make out the one solid slice with the page this way up, but when you do so you are in effect looking at the plate from underneath. Our habit is almost always to look at plates and cakes from above, and seldom from below.

"Schröder's staircase" is a similar phenomenon. You will first see it in its usual position. After a while, it will suddenly turn upside-down. If you find the latter difficult to perceive, it may help if you insist that one end of a step is first nearer than the other and then farther away.

In the famous ambiguous picture designed by the American psychologist E. G. Boring, there is no generally-accepted obvious way of interpreting its meaning, although one or the other always tends to dominate at first. You will either see a young girl or an old

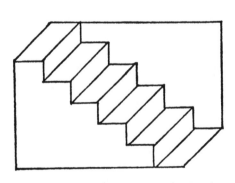

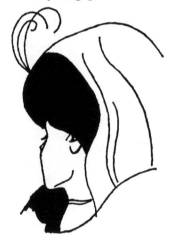

crone, depending upon which visual clues first suggest themselves for transmittal to the brain, maybe depending upon your own sex and age. In time, though, the image will change. The chin of the girl becomes the nose of the crone, the ear of the former the eye of the latter. If you cannot see the change straightaway, when it does come its effect will be quite dramatic, literally as if Merlin had suddenly waved his wand.

Body Trick 16

Many interesting effects can be attributed to the principle of irradiation, whereby a brightly-illuminated object will appear larger and more prominent within its surroundings than one less bright. In the illustration shown, although the small inner squares are identical in size, the white one appears larger than the black one at the expense of the black margin.

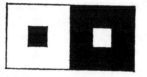

What happens on the retina when this occurs can be likened to the halation on a photographic negative, when light spreads beyond its proper boundary. Thus the retinal cells adjacent to those actually stimulated by the bright image are themselves activated to a degree. If you have ever observed the sun setting beyond a straight horizon, you may have been puzzled as to why a dent should appear on the earth where the sun goes down. This is irradiation again, causing the sun to look bigger than it actually is and to overlap the horizon in the process.

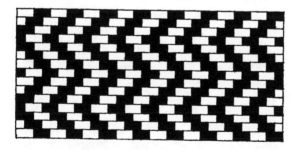

Nowhere is the effect of irradiation more tantalising, however, than in the mosaic above, where the sharp changes from white to black produce the illusion that not only are the tiles themselves uneven but that they have been very carelessly laid into the bargain.

A simple test with a ruler, however, should quickly absolve any workman from blame.

Body Trick 17

Descartes, the philosopher, is said to have looked out of his window at the movement of hats and coats in the street below and exclaimed, "I see men down there." On the occasion in question, he was baiting argument. While there were almost certainly men down there, he knew only too well that he could see neither their faces nor their bodies. They might, for all one could state categorically, have been merely scarecrows motivated by some historically advanced form of remote control.

The anecdote serves to illustrate how the brain is in constant danger of investing the information it receives from the senses with preconceived assumptions, and being tricked in the process. Sight, being the busiest of these senses, tends to take more for granted than most, relying on a vast memory bank in the brain, which enables it to recognise the familiar with little effort and to concentrate on more interesting phenomena than the man in the street. It is to the good that each time we meet our friends we do not have to inspect them to check that they are the same people we saw a day or two ago. Occasionally, however, the system will fail.

The psychologist Jerome Bruner devised an intriguing test which capitalised upon our shared assumptions concerning the suits of playing cards, namely that spades and clubs are black, hearts and diamonds red. He deliberately transposed the colours of several cards in a pack, so that it then boasted, for example, a *black* ace of hearts, a *red* five of spades. Flashing the cards quickly on to a screen, he asked observers to name them. Many people did not see the outlaw cards as they were, but corrected them, so that a red three of spades was described as the three of hearts and so on. Only when it was suggested that hearts need not always be coloured red, did most observers latch on to the ruse.

In another experiment to show how assumptions may vary according to our needs and intentions, Bruner studied children from rich and poor homes. He found that the latter tended to consider a given coin larger than children of the same age from more affluent families.

There is a test which anyone can set up to show how prior conditioning—here, that large objects will be heavier than small objects—can influence perception and the subsequent actions we base upon it, only to produce an illusion. Find a large and a small tin and then fill the latter to the point where it weighs the same as the large tin. Anyone who is ignorant of your behind-the-scenes preparations and

lifts the two tins together, one in each hand, will find that the large tin feels much lighter. Further, if he then places an empty tin on top of the small tin, somehow the two together will feel lighter than the small tin by itself. What happens is that, influenced by the apparent information conveyed by the relative sizes of the tins, a person will unconsciously key his muscles to lift the weights he expects. And, of course, he gets a surprise.

Nothing shows more vividly the way in which we see what our assumptions lead us to think we see than the experiment carried out by the Russian film director Poudovkine. Having filmed an expressionless close-up of the actor Mosjoukine, he intercut the same shot in such a way that it followed on from footage of a plate of soup, of a young girl lying dead in her coffin, and of a child at play respectively. Then he showed the finished print to an audience, who had to report what they saw. They all noticed how the actor gazed hungrily at the soup, sadly at the death scene, happily at the child. And yet they had seen the same impassive face three times. Preconceived ideas can more than lead you astray. They can actually make you see what simply does not exist.

Body Trick 18

That we are able to see the world in three dimensions is due largely to the fact that we have two eyes. Both receive a slightly different retinal image of whatever we observe and it is partly from the disparity between them that we are able to de-code depth and distance. To prove how bad a judge of distance a single eye can be, place a cork on the edge of a table. Walk slowly backwards ten or twelve feet, with both eyes fixed on the cork. Then, with one eye closed and your right hand extended, walk forward quickly and knock it to the floor with one blow of your forefinger. The likelihood is that you will miss it altogether.

Another test that demonstrates the same principle requires two pencils, one held in each hand. With one eye still closed, hold them apart, with their points towards each other, not quite at arm's length. Then move the pencils towards each other so that their points touch. It sounds easy until you try. If you decide to repeat the test, it is suggested that you drop your arms out of vision before you try again. This destroys any depth clues you might begin to pick up from the position of your hands and arms.

Body Trick 19

Binocular vision – namely, the combined efforts of both eyes – is

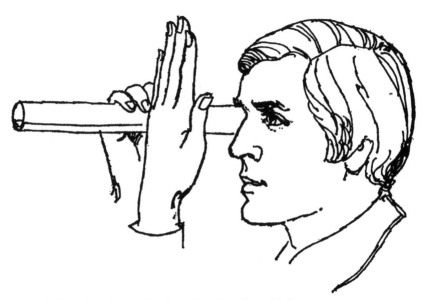

responsible for the following illusion in which you apparently see through a hole in your hand. Roll a sheet of paper into a tube and secure it with an elastic band. Hold it in your right hand up to your right eye like a telescope. Look through it, focusing your vision on the wall ahead. Now hold your open left hand, its palm towards you, its edge against the tube, in front of your open left eye still focused ahead. Both images will fuse, so that you appear to receive only one. Consequently, the hole in the tube appears to be in your hand. You will have to slide the hand along the tube until you find the exact spot where the hole appears to transfix the exact centre of your palm. Then the illusion should be perfect.

Body Trick 20

The following experiment in self-contained levitation is of the same kinship. Hold the outstretched index fingers of each hand horizontal, with their tips touching just a few inches in front of the bridge of

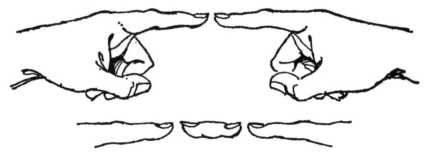

your nose. The other fingers are bent back into the palm. Fix your gaze upon a point on the wall ahead in such a way that you can still see your fingers out of focus. Only then separate the fingertips slightly. You will see something remarkably like a sausage, except for the nail markings on each end, floating unaided between the two index fingers. Do not however focus your eyes on the fingers or the "sausage" will disappear.

Because your eyes are focused in the distance, the retinal image pertaining to near objects in the right eye is prevented from fusing properly with its counterpart in the left. The two images become staggered in such a way that you see the tip of each finger twice. Hence the "sausage".

It is even possible to make money grow by a similar overlap process. Place two identical coins an inch or two apart directly opposite you on a flat surface, and then take a pencil and hold it vertically between the coins. With your eyes focused on its point all the time, slowly move the pencil towards your face. At first you will see the two coins separate into four. Then comes a moment when the pencil is positioned exactly between the left eye and the right coin and between the right eye and the left coin, at the crossroads, in fact, of the two paths formed by them. At that point, the two inner coins will fuse into one. It is important, however, that you keep your focus on the pencil throughout. As soon as you actually focus on the coins, as distinct from being aware of them in the background, the illusion will cease.

Body Trick 21

Make a pendulum by tying a small weighted object to the end of a piece of string. Ask a friend to stand opposite you and swing the pendulum from side to side on a level with your head. Keeping both eyes open, hold a pair of dark sunglasses over your right eye only and look at the pendulum. Although you know it is swinging from side to side in a plane perpendicular to your line of vision, your eyes will tell you otherwise, namely that it's swinging clockwise in an elliptical path. For an even greater surprise, transfer the dark lens to your left eye. As you do so, the pendulum will appear to change rotation and start to swing in a counter-clockwise direction.

This happens because the dark lens, in cutting out light, delays the signal transmitted to the brain from whichever eye it is covering. Consequently, the two images that comprise our normal binocular vision become stepped in time, the picture the brain interprets from the darkened eye arriving a split second later than the other one, with the result that at any given moment one of the two images that do actually fuse in the brain is fractionally out of date. When the

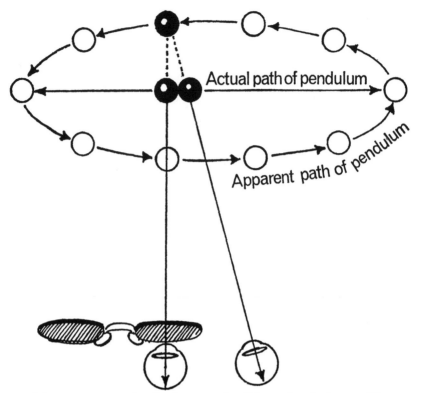

Actual path of pendulum

Apparent path of pendulum

pendulum comes to the furthest reach of its swing it is travelling at its slowest and in fact becomes still for a moment, so that little discrepancy is seen. The slow eye has time to catch up with the brain. When it reaches its fastest speed, however, at the middle of the swing, then the discrepancy between the two images is naturally at its greatest, causing the pendulum to appear either in front of or behind its actual plane, according to whichever eye is covered by the dark lens. This phenomenon was first outlined in the Twenties by the German scientist Pulfrich, all the more remarkably in that he worked it out completely from theory. He was blind in one eye.

You can use the same dark glasses to witness another curiosity based on binocular vision. Again with one eye covered as before, it is possible to obtain a three-dimensional effect from watching a standard television screen. This only works with movement across the screen, never up and down, and even then the movement should ideally be related to something stationary within the frame. To appreciate fully movement from left to right, you should cover the right eye and vice versa. If you can imagine the person moving, whether soccer player or cowboy hero, in place of the pendulum, you should have no difficulty in working out why they can be made to appear a considerable distance in front of the glass screen on which they originate.

Body Trick 22

Another aspect of vision which can apparently play tricks with the brain is colour. The light-sensitive nerve endings within the retina are divided into two categories, rods and cones, named after their approximate shapes. The rods respond merely to shades of grey, while the cones provide us with colour vision. The generally accepted theory of colour, first developed by Thomas Young in 1801, depends on the existence of three different kinds of cone, each group sensitive to one of the primary colours – red, green and blue. Any colour in the spectrum can be matched by a mixture of these three, provided they are set at the appropriate intensities. When one or more of these groups of cones fails to function, the result is colour-blindness.

Colour itself is never contained within an object. Its secret is light. The difference between all seven colours of the rainbow is the difference between the light wavelengths at which each colour is set within the spectrum. When we describe a flower as yellow, it means that the petals are absorbing all the colours with the exception of the one which we see, the wavelength of which it reflects back for our brain to interpret as colour.

Although it sounds impossible, one can conjure up colour wavelengths from mere black and white. Experimenting to find the best speed, spin a copy of the left disc below either on a 78 rpm gramophone

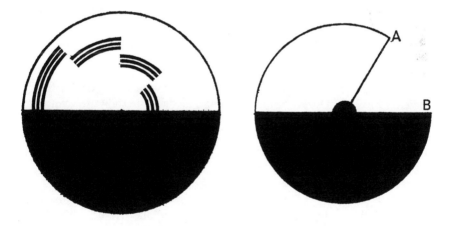

turntable or stuck on cardboard as a makeshift top with a pencil through it. In time you will see a series of concentric coloured rings, red around the circumference and bluish-green at the centre. Reverse the direction of the spin and the order of the colours becomes reversed.

Much controversy exists as to why this should happen. The colour-signalling apparatus of the retina must somehow be tricked by the varying black and white pulses of the spinning disc into believing them to correspond to the appropriate colour wavelengths. No one, however, not even Gustav Fechner, the nineteenth-century German physicist, arguably the first to construct the disc, knows the exact answer, although Richard Gregory possibly comes closest in this explanation from his book, *The Intelligent Eye*:

> ... the three retinal colour systems have (in electronic terminology) different time-constants. The rotating disk gives intermittent stimulation to the colour receptors. It is probable that the red-, green-, and blue-sensitive receptors have somewhat different time constants, so that repeated flashes of light build up different levels of activity in the three systems — which is equivalent to a coloured light to the brain.

A related illusion involves mounting a copy of the second disc on to cardboard. Cut out the segment between a and b, then pierce a knitting needle through the centre so that the disc will rotate freely around it. If you now hold the needle by its pointed end, so that the disc is suspended a few inches above a page of newsprint, and spin the disc at the rate of five or six rotations a second, the letters beneath the card, seen as a result of the gap in the disc, will appear a reddish colour. It is important, however, to avoid shadows and to make sure that the page is brightly lit.

Body Trick 23

The subject of colour leads us back inevitably to the discussion of after-images produced by the retina. We have seen how the light-sensitive cells of the retina become fatigued under the constant stimulus of a given shape; the same applies to the stimulus of a given colour. When the eye becomes overburdened with one colour, it compensates with an after-image in its complementary hue once the original is removed. A complementary colour is one which, when mixed with its opposite, will produce white or a neutral tint.

Paint on paper a tricolour flag of any colour combination — say green, black and orange — in strips of equal width from left to right. You will also need a large sheet of white card. Prop the flag up against an ornament and stare at it for half a minute. Then cover it with the card, but keep on staring. Once your eyes have had a chance to readjust themselves, you will see a flag of totally different colours, these being complementary to the original three, namely, red, white, and blue.

This is not the only way in which you can observe complementary colours. Place a small square of grey paper on a vividly coloured background. Keep your stare fixed upon the square and in time it will appear fringed with a border in the colour complementary to the background. This is made possible by the combination of the after-image obtained and the displacement of the same caused by involuntary eye-movements. Even more curious is what is known as "Meyer's experiment". You need the coloured background and small grey square as before, but this time you cover both with a large sheet of plain white tissue or greaseproof paper. When observed through the semi-transparent paper, the grey square will appear evenly tinted all over with the appropriate complementary colour. And so red once again will give green, yellow blue, white black, but – this time – instantly.

Body Trick 24

There are several optical illusions in which it is possible to suppress or re-create the illusion at will, depending upon whether or not we wish to ignore some outer point of reference within the environment. The most familiar example is when the train standing next to the one in which we are travelling starts to pull away slowly and smoothly from its platform and there is a brief moment when we are unsure whether we are moving or not.

When we ourselves move forward our entire field of vision glides backward over the retina. When that movement is due to the progress of a train, we become one with the carriage and the part of our field of vision which is allowed to glide past is restricted to that framed by the train window. Consequently, whenever we see a window with all the objects visible through it moving in one direction, we interpret that as movement on our part. When another train passes alongside and fills the entire window with its own movement, confusion sets in, provided that we do not catch a glimpse of any part of the station at the same time. At the moment we do so, the illusion of our own movement promptly disappears.

Less familiar, although dependent upon a related principle, is the illusion of movement obtained by staring steadily for a long time – at least a few minutes – at a fast-moving stream or river. Suddenly avert your gaze to the ground at your feet and you will, for a brief while, obtain the illusion that the ground is moving in the direction opposite to the water. The same occurs to the boards on the deck of a ship if you first look over the rail at the water rushing alongside. Equally disconcerting is the sensation of staring first at a rapidly-moving procession of people, then at the ground and seeing the pavement move.

Illusions of movement of this kind depend upon the unconscious movement of the pupils themselves. When we gaze at a river or in fact any object which passes continuously in front of us in one direction, it carries our eyes with it. If it keeps passing towards our right, the eyes keep following the focal point within the object until that point disappears from comfortable view, whereupon they jerk back to the left again to catch a new focal point, and so on, ad infinitum. The more this oscillation persists, the longer it takes the eyes to settle down when we shift our gaze to a new expanse. Being unconscious of the automatic movements still being made by the pupils in one direction or the other, we suppose that the new surface at which we are looking is itself on the move.

The illusion need not be confined to horizontal movement. The next time it snows, go outside and fix your gaze on just one snowflake. Follow its fall with your eyes and then just before it reaches the ground, look up, select another flake, and so on. After several minutes look at the ground. Either it will appear to rise up around you or you will feel as if you are actually sinking into it.

4 An Ear For Magic

The most startling aspect of the ear is its miniaturisation. No other part of the body manages to compress such a wealth of activity and organisation into so small an area – the entire mechanism for hearing and balancing takes up a space no larger than a marble.

The simple, almost comical flap of skin at the side of the face is only the gateway to a world of extreme precision and delicacy. Technically known as the outer ear, it is skilfully designed to collect sound waves, the vibrations made on the air by the source of the noise to be heard, and channel them through a canal one inch in length, until they reach the eardrum, a thin membrane that vibrates in response. These vibrations pass directly on to the adjacent middle ear, a cavity no more than a third of an inch wide and a sixth of an inch deep, dominated by three small bones hinged together and whimsically named hammer, anvil and stirrup after the ironmongery they fleetingly resemble. The ossicles, as they are collectively called, are capable of amplifying the movements of the eardrum twenty-two times. By resounding on the inner ear, the stirrup, the last of the three, passes on the vibrations through a layer of fluid to the main organ of hearing, the snail-shaped cochlea. Here the initial sound waves, after finding the nerve cells which respond to their particular vibration, are transformed into nerve impulses which connect with the auditory centres of the brain to become intelligible sound.

An indication of the extreme delicacy of the system may be obtained by measuring the vibrations to which the ear will respond. The effect of a whisper on the eardrum may be a displacement of only one millionth of a centimetre, and yet it can still be heard. It is no wonder that such an intricate chain of transmission is essential within the ear. When sound waves strike a solid object, most of their energy is usually bounced back. This is the challenge met by the ear, to absorb the maximum energy from the vibrations that hit the eardrum and conduct it to the inner ear with the minimum loss. It does this by progressively increasing the force of the vibrations at the same time as it reduces their size. By the time it is transferred to the membrane of the inner ear that connects with the brain, the vibration set up by a whisper will be almost a hundred times smaller in size than it showed itself to be at the eardrum.

Body Trick 25

The system described above is the principal, but by no means the

only avenue by which we listen to sound. It is also possible to hear by bone conduction, something easily proved by clicking the teeth, munching celery, or, more scientifically, by striking the prongs of a fork sharply against a hard edge and then, without delay, firmly applying its handle to the bone behind the ear. You will hear a distinct sound, one which will vary depending upon which bone you bring into contact with the fork. The most resounding result will come when you clench the handle between your teeth. For a better effect, try it with your ears plugged.

When we hear ourselves speak, we are listening to a combination of sound conducted by air waves through the outer ear and sound carried direct to the auditory nerves of the inner ear by bone conduction via the jaw. For this reason many people have difficulty recognising their own voice when played back on a tape recorder. The exclusively air-conducted sound which the person to whom we are speaking hears is obviously thinner than the sound we ourselves interpret.

For another test, tie a metal coathanger to the centre of a piece of thread or thin string about four feet long. With the tips of your index fingers press one end of the string into each ear, keeping the fingers there to cut out external noise. With the coathanger dangling freely in front of you, ask someone to tap it with a fork. It will sound like Big Ben. In this instance the sound vibrations are transmitted along the string to the bones of the ear which will still hear them, even though to all intents and purposes the ears are closed.

Place your watch at one end of a long wooden table and go to the other. Stop one ear with your index finger and press the other against the wood and you will hear the ticking of the watch distinctly, even though it may be quite inaudible in the atmosphere.

People who are deaf due to a defect in their inner or middle ear may still be able to hear by bone conduction. It is said of the deaf Beethoven that he could hear a piano being played by placing one end of his walking stick against it and gripping the other end between his teeth. An old test, long used by deaf violinists, involves the afflicted musician applying his teeth to some part of his vibrating instrument. If he can still hear no sound, that means that the auditory nerves in his inner ear are gone and that his deafness is past cure.

Body Trick 26

Sound waves are capable of amazing things on their way to our auditory nerves. They can even be rendered inaudible in a most uncanny fashion.

You will need a fork again, although a tuning fork—with only

two prongs—will prove more effective. Strike it sharply against the table as before, then hold it vertically, with the prongs uppermost, close to your ear and twist it slowly. The sound from the fork will alternate between loud and soft and quite probably there will be some points where you will be unable to hear it at all.

This is caused by the interaction that takes place between the sound waves emanating from opposite sides of the fork. Imagine a sound wave as a wavy line in keeping with its name. When two waves of similar volume and pitch come together in such a way that the crests of one coincide exactly with the troughs of the other, then they cancel each other out and produce silence. Similarly, when crest meets crest and trough meets trough, they become higher and deeper respectively and their sound is magnified as a result. As the opposing sound waves go in and out of step in relation to your ear, both phenomena occur no less than four times in one complete rotation of the fork.

Body Trick 27

When we hear an echo, it means that a wall, a mountain or some similar obstacle is reflecting sound in the way that a flat mirror reflects light. Similarly, just as a concave mirror concentrates rays of light to a single point, it is also possible to have a concave sound mirror that will focus sound waves and, for our purposes, produce a curious illusion in the process.

Find two identical soup plates. Place one in front of you on the table at which you are seated and hold your watch inside it an inch or two from the base. Hold the other plate to either ear and then, by carefully adjusting the position of all three objects, you will begin to hear the ticking of the watch as if it were actually coming from the dish which you hold. Close your eyes and you will be quite unable to tell by ear alone which hand is holding the watch.

Body Trick 28

An illusion need not necessarily be the monopoly of just one of the senses; erroneous assumptions are more than likely to cross over between them. In the same way that sight and touch were deceived together in the tin-can test in the previous section, so touch and hearing can also be confused.

Find a flat clothes brush with fairly soft bristles and a volunteer. Standing behind him, stroke his back firmly with the fingers of one hand, at the same time as the other brushes *your* jacket in perfect

synchronisation. His brain, led astray by a combination of past experience and false assumption the moment it sees the brush, pieces together the information it receives from the downward pressure felt on the back and the sound of the bristles heard through the ears, and reports back to its owner that you are actually brushing him down. A perfect illusion results.

Body Trick 29

In the same way that binocular vision enables us to interpret our environment in three dimensions, so the possession of two ears enables us to locate the direction of sound. When noise originates from any-where other than directly ahead or straight behind us, the volume received by one ear will always sound louder and be heard sooner than that received by the other, because one ear will always be nearer the source of the sound. Even though a sound originating from one's immediate right reaches the right ear only approximately 0·0005 second before it arrives at the left one, this discrepancy is then mysteriously translated by the brain to pinpoint its position.

The principle of binaural hearing can be tested in an amusing fashion by blindfolding a volunteer and asking him to sit in a chair in the centre of a room away from helpful echoes. He must remain still and not turn his head. If you now click together a couple of coins anywhere to his right and ask him to point in the direction from which he hears their sound, he will do so correctly since his right ear hears the sound that degree more distinctly than his left. The same applies when the coins are clicked somewhere on his left side. Imagine, how-ever, a plane slicing vertically through his head in profile, and then click the coins anywhere in this area, under the tip of his chin, say, or halfway between his eyes, even between his knees. The subject will usually be way off beam in his assessment of the source of the sound. It is to such shortcomings in a spectator's hearing apparatus, once enhanced by his imagination, that ventriloquists owe their living.

Body Trick 30

The fact that we possess two ears plays a considerable part in the effect known as the "Cocktail Party syndrome". If you have ever stood in the centre of a crowded room with what seemed to be countless small groups chattering all around, you may have been surprised to discover how easy it is to tune into what one person is saying to the almost total exclusion of everyone else, and then out of this into some-body else's conversation at the opposite end of the room. Even a person

engaged in deep conversation in such a situation is likely to prick up his ears when someone in another group happens to mention his name and address or some other detail of strong personal meaning to him, even though he is not expecting it and his attention is directed elsewhere. In a similar fashion the conductor of a symphony orchestra can single out from the blended sounds of all his musicians, a performer who is not living up to expectation.

No effect provides a better demonstration of the truly remarkable level of selectivity with which our senses, or, more accurately, the brain in its interpretation of them, are equipped. In the context of this gift the cocktail party effect is really nothing to shout home about. In different guises it is happening all the time. It appears remarkable here because we are so seldom aware of the tuning process when it takes place, programmed as we are to act in certain ways without realising. During the summer we tend to sweat more profusely as well as to take more salt than usual in our food. The one in fact conditions the other; the fact that we need more salt as a result of sweating does not have to cross our minds in order for us to make up the bodily deficit. Likewise, we are programmed to an extent by past experience to know what to expect to follow on the printed page or in conversation. A coherent sentence will be interpreted more readily than an arbitrary jumble of words. Once you have singled out one voice to listen to in a cocktail party situation, it becomes far harder to transpose totally unrelated words or interjections from another equally audible conversation than to keep your attention fixed exclusively on the original, helped as you are by the consistent quality and direction of that speaker's voice. What appears to be an extraordinary phenomenon is, in some ways, not so remarkable after all.

Body Trick 31

The study of auditory illusions does not reveal the mass of tradition – a seemingly infinite labyrinth of puzzles and philosophy – upon which its optical counterpart is firmly based. This is largely because sound is by its very nature ephemeral and was, until the invention of recording, virtually impossible to reproduce and manipulate in the controlled scientific fashion long accorded to visual stimuli. The emergence, however, of sophisticated recording and playback equipment has now turned the tide.

Before we leave the cocktail party of the previous trick, we should pause to reflect how impressive it is that amid a hubbub of eating and laughter, glasses clinking and maybe music blaring, we can make coherent sense of any conversation at all. In fact, one is able to compensate for whatever words and syllables are obliterated by

interference, in such a way that the disjointed sounds one does hear become complete statements.

An ingenious experiment to show what exactly happens in such a situation was devised by psychologists Richard and Roslyn Warren of the University of Wisconsin. After recording the sentence, "The state governors met with their respective legislatures convening in the capital city", they carefully deleted one phoneme, namely the speech sound of one letter, together with any tell-tale sound on either side of it that might give away the missing letter. In this case they took out the first "s" in "legislatures". They then inserted a cough of the same duration as the phoneme in the resultant gap. When they played their sentence back to an audience, they were able to confirm that they had created an illusion whereby people heard the missing phoneme as if it were still there. Even when it was explained to them how the tape had been doctored, they were unable to identify the illusory speech sound. Surprisingly the cough gave no help, appearing to have no precise location within the sentence and co-existing with the other phonemes without tampering with their intelligibility. Even when the Warrens substituted an arbitrary sound of the same duration for the entire syllable "gis", the illusion persisted.

The answer is to be found in the way the brain handles verbal context. With the sentence in question sufficient information is received by the brain for the sentence to be rendered complete prior to the substituted sound coming around. Further experiments have revealed, however, that the illusion still works when the context necessary to complete the sentence does not occur until after the deleted sound. Consider what happens when you substitute a cough at the point where the asterisk occurs in the sentence, "It was found that the *eel was on the ———". This sentence was recorded four times, on each occasion with a different last word, namely "axle", "shoe", "orange", and "table". In each case a different speech sound was heard at the asterisk, namely "wheel", "heel", "peel", and "meal" respectively. Apparently the process of hearing here involves storing the incomplete information in the memory until the complete sentence is heard, whereupon the listener then unconsciously restores the appropriate phoneme.

Body Trick 32

Another experiment devised by the Warrens to demonstrate the importance of a meaningful context in determining accuracy of hearing, involves the subject listening over and over again to a sequence comprising a hiss, a tone and a buzz, each lasting a fifth of a second without pauses. It would appear to be the easiest of tasks to designate the

order in which the sounds, at least twice as long as a phoneme in normal speech, are heard, but this is not the case. Apparently the pattern races by, resisting any attempt to confine it to a temporal straitjacket. The number of people who named the sequence correctly in the laboratory was just less than the level of chance. It does not even help to concentrate on one of the sounds and then having decided on the one that follows, to arrive at the third in sequence.

Similar results were forthcoming when the experiment was expanded to take in a sequence of four sounds comprising high tone, buzz, low tone and hiss. However, when spoken digits, namely, "one", "three", "eight", "two", each lasting the same fifth of a second, were repeated over and over, the subjects had no difficulty in determining the order. This was in spite of the fact that the four digits were recorded individually and then spliced together into a loop to obliterate the possibility of help from tell-tale transitional cues. It follows that to make an accurate assessment of temporal order by hearing, one may need to encounter sequences reminiscent of normal speech patterns. On reflection just such a limitation would appear not only to make the cocktail party effect possible (refusing as it does to make extraneous sounds part of an already integrated temporal pattern) but also the exact location of the extraneous cough by the listener in the "state governors" sentence impossible.

Body Trick 33

What follows is, in effect, a sound analogy to the optical illusion typified by the Necker cube with its spontaneous reversals of perspective as detailed in the last section.

The Warrens recorded the single word "tress" over and over again on a continuous loop without pauses at a rate of 120 times a minute for three minutes: "tresstresstresstress . . ." They assumed that somebody, listening intently with no indication given as to where one word commenced or ended, would in time begin to hear illusory words such as "stress" or "rest". Any word continually repeated would be subject to such changes. They did not reckon, however, with the far more startling effect which the absence of any context produced. To their surprise, the illusory words experienced extended over a far wider range. The average subject not only registered about thirty changes within the three-minute span, but changes ranging over at least six different words as varied as "stress", "dress", "Joyce", "floris", "florist" and "purse". It is as if refusing to believe he would be subjected to a meaningless chant of a single word, the subject tries to order the sounds heard into coherent speech patterns. This theory is strengthened by the fact that children at or below the age of six as

well as adults over sixty-five experience relatively few illusions of this kind, reporting the same word taped over again and again correctly. The former have not yet reached that age where the level of verbal input processing required can be expected, while, according to the Warrens, the deterioration through old age of short-term memory would appear to argue for a parallel diminution in the same processing powers in elderly folk.

Body Trick 34

An interesting illusion with a musical, as distinct from verbal pedigree has recently been discovered by Diana Deutsch, a psychologist with a strong interest in music, at the University of California in San Diego. As part of a research programme to determine how the brain sorts and orders independent tones into musical combinations such as melodies and chords, she fed to both ears of her subjects, through earphones, the identical sequence of alternating high and low tones, but in such a way that they were staggered: When the right ear was presented with the low tone, the left ear was receiving the high tone, and vice versa. Each tone lasted exactly one quarter of a second, while the entire sequence ran for twenty seconds.

It was discovered that very few people hear what one might expect, namely a single uninterrupted two-tone chord. Most right-handed listeners report hearing only a single high tone in the right ear, alternating with a single low tone in the left. When the earphones are reversed, the right ear still registers the high tone, the left ear the low one, the function of the earphones appearing to change over as far as the subject is concerned. Left-handed people are just as likely to register the high tone in either their right or left ear, a fact consistent with our knowledge of cerebral hemisphere dominance.

The most baffling aspect of the whole procedure is that the low tone should be heard by the non-dominant ear (i.e. the left ear in a right-handed person), when it is in fact receiving its own high tone. It is not enough to surmise that the dominant ear is *so* dominant that the listener ignores the input of the other under these conditions. If that were so, the alternating tones would register in that ear alone. On the other hand, that he is attending to each ear in turn is ruled out by the fact that then the tone heard shifting from one ear to the other would remain constant.

That high and low tones are heard to alternate between ears could be explained if one had evidence that the brain localises the tone it registers from the dominant ear in the area of the ear receiving the higher tone. In other words, it listens to what the dominant ear receives, but appears to hear its input in the opposite ear on those occasions when

the latter receives a higher frequency. This hypothesis was proved by the results of another experiment devised by Deutsch, in which three consecutive high tones were presented to the dominant ear at the same time as three low tones were presented to the other. Then two low tones were fed to the dominant ear while two high tones were fed to the other. This was repeated with headphones reversed on opposite ears. The results confirmed that people hear only the sounds presented to the dominant ear, but localise them in the ear receiving the higher volume.

Another way of experiencing the illusion is to stand in the centre of an echo-free room, equidistant between two loudspeakers, one on either side. At first you will hear the high tones on your right, alternating with the low tones on your left. Then rotate slowly through 180 degrees. At the conclusion of your turn the high tones will appear to emanate from the loudspeaker that originally emitted the low tones, while the low tones will appear to emanate from the other. Stop, however, for a while after ninety degrees, when you are facing one of the speakers, and you will at last hear a single tone of constant pitch which apparently comes from them both. Something like the sound you might expect to have heard when you first put on the earphones.

5 Tantalising Tastes And Mystic Smells

Taste and smell are the only senses which depend upon chemical as distinct from physical stimuli; together they comprise an area relatively free from illusion and misunderstanding of the kind seen at play in the previous two sections. In this area one can speak only subjectively, a fact which accounts for the difficulty of describing accurately the sensation of a new smell or taste, however memorable, to someone ignorant of it. To succeed in communicating verbally the aroma, say, of Christmas pudding to a Chinaman or of kangaroo breath to a Russian, is as elusive an achievement as success in describing colour to someone blind from birth.

No fewer than forty different theories have been advanced in the last hundred years for explaining the sense of smell. Prominent among these is the theory that scent is all a matter of shapes. Everything that we smell throws off molecules which are wafted by air towards the approximately ten million olfactory cells that comprise the sensitive nerve endings situated on the roof of both nasal cavities. Each odour, varying molecularly in size and shape, stimulates a specific pattern amongst the receptor cells which then, by an electrical charge, dispatch the information to the olfactory lobe in the brain, where the smell is eventually registered. The exact mechanism, however, remains a mystery.

It is generally accepted, however, that there exists only a handful of basic odours – the equivalent, nose-wise, to primary colours – and that all smells comprise a different combination of these. The most famous list of categories was drawn up by Hendrik C. Zwaardemaker, a follower of the naturalist Linnaeus, in 1895. He proposed nine divisions as follows:

Ethereal	*fruits, resins, ethers*
Aromatic	*camphor, cloves, lemon, almonds*
Fragrant	*flowers, vanilla*
Ambrosial	*amber, musk*
Alliaceous	*garlic, sulphur, chlorine*
Empyreumatic	*burnt or roast odours*
Caprillic	*cheese, fat, sweat*
Repulsive	*deadly nightshade, bed-bug*
Nauseating	*rotting meat, faeces*

In recent years, odours have been reduced more fundamentally and therefore realistically to just four classes: fragrant or sweet; acid or

sour; burnt or empyreumatic; caprillic or goaty. Ernest C. Crocker and Lloyd F. Henderson have devised a formula whereby any smell can be represented by four digits, each one signifying the strength of each component on a scale from one to eight. Thus the coding 7122 for vanilla means that it is exceptionally sweet, minimally acid, and only slightly more burnt and caprillic. However oversimplified such a theory might appear, it would argue for four types of receptor among the olfactory cells, the same number that we know does exist amongst our 9,000 taste buds with which to register taste.

The four primary taste sensations are sweet, sour, salt and bitter and each has its own special territory within the mouth. Although some taste buds are situated on the palate, tonsils and in the upper throat, the tongue is the central stage. Its tip is more sensitive to sweetness than any other part because the highest concentration of sweet-taste receptors is located there. Hence the tendency to sip sherry is no more an arbitrary whim than the habit of throwing beer well to the back of the tongue where bitterness predominates. Likewise, saltness and sourness hold sway at the sides, the former near the tip, the latter more centrally. All tastes are a combination of the effects by food on the four basic taste receptors, modified occasionally by that made on the ordinary nerve endings, like the burning sensation of curry. However, all the taste buds in the world would be no more than a cipher, if it were not for the part played by moisture in helping them secure the taste itself.

Body Trick 35

Before you can taste any food, part of it must be dissolved in water. Without saliva it is impossible to taste any solid object, a fact which you can prove to yourself by following these simple instructions. First wipe your tongue dry and then sprinkle sugar on its tip. You will taste nothing until you allow your mouth to water again. Even ice-cream is flavourless until it melts.

While no one knows exactly how the taste buds gather the information they transmit electrochemically to the brain, it is accepted that they can only do so if liquid is present to bind the food to the appropriate — whether sweet, sour, salty or bitter — taste receptors.

Body Trick 36

Just as the receptor cells of the retina become fatigued when exposed too long to a single visual stimulus, so those that register taste undergo a similar process of distortion. First mix a strong solution of water

and sugar and roll it around the mouth for several seconds, without necessarily swallowing it. Gradually it will taste less sweet. Next take a glass of fresh water and taste it. It will taste so salty you will find it hard to believe you haven't added salt to it of your own accord. However, all that has happened is that the taste buds responsible for sweetness have been phased out temporarily, thus giving those responsible for salt extra prominence. In the same way, an extremely sour solution will make fresh water taste surprisingly sweet if sipped immediately afterwards.

Likewise, we become overwhelmed by individual smells. A new neighbour, depressed initially by the odours of the gasworks or sewage farm nearby, soon finds that he hardly notices them. And yet his sensitivity to other odours, like the fragrance of a rose or the piquancy of home cooking, is in no way dimmed. It may even be enhanced.

Body Trick 37

One other factor plays an important part in taste, namely smell. Without realising it, we scent every single thing we consume, whether via the nostrils or the rear access to the nasal opening at the back of the throat. This combination of smell and taste results in flavour, a more comprehensive range of experience which it would be impossible for the four basic taste sensations that originate in the mouth to encompass on their own. Some things—roast beef, salmon and cabbage, for example—rely almost entirely on aroma for taste. When next you eat any of these, hold your nose before the food comes too close to your mouth. Then place the food on your tongue. It will be tasteless. When you inhale through your nostrils, however, its taste will return.

This should place into clearer perspective why we taste less when we catch a cold—because the infection tends to block our nasal passages, thus preventing the smell of the food we eat from registering in the brain. Consequently, we have to make do with the mere distinction whether the food is sweet, sour, salt or bitter.

A mock hypnotic stunt long used on the vaudeville stage involved the showman displaying a red and a green apple to his victim prior to blindfolding him. He was then told to pinch his nose and to guess from taste which apple he has been offered. In fact, the charlatan would cut a slice not from the apples but from a potato. Not only would the victim be unable to guess the truth, but he would actually swallow the vegetable before the error was drawn to his attention. Under similar conditions you will find that orange squash tastes the same as lemon, which similarly doubles for lime juice. Possibly the most intriguing demonstration of how smell can affect taste involves eating an apple at the same time as you hold a more pungent pear

beneath your nostrils. The smell of the pear will obliterate that of the apple to such an extent that the flesh of the apple you eat will assume the flavour of the pear.

Body Trick 38

However vividly you can imagine that you see before you a black cat, a snowflake or an elephant, you still know it is not there. However vividly you can conjure out of thin air the sound of a child playing, a cow mooing, or a brass band blaring, you still know that the sound is non-existent. Smell and taste, however, would appear to exert a stronger, far more realistic hold on the imagination. Students of hypnosis have long been aware that suggestibility is far more potent in these two lowest senses. The suggestion that the subject experiences the taste of gooseberries, or the smell of mulligatawny soup, is much more certain to work than one which makes out that he will see the Taj Mahal in front of him when he opens his eyes. Not that hypnosis – a facet of our subject which we shall discuss later – is essential. The very mention of those distinctive foods will have evoked their tastes and smells in the most sceptical reader.

The idea is especially effective with tastes and smells that transport you back to childhood. The incident in Marcel Proust's *À la recherche du temps perdu*, where the narrator is carried back through time by the taste of a madeleine dipped in tea, is the most famous in the entire sequence of novels. Surround yourself with tastes and smells that recall your younger days. It may be the tang of rusks, orange cake, or chocolate brownies, the scent of nursery soap, plasticine or woodsmoke. Not only will you travel back in time, but you will also find yourself experiencing a torrent of memories more vivid than any conscious intellectual exercise could produce, so vivid that for a moment, like "Marcel" in his boyhood town of Combray, you are actually there.

This high potential for suggestibility amongst the chemical senses was discussed as a source of illusion by William James in his monumental *The Principles of Psychology*. He quoted from the German G. H. Meyer:

We know that a weak smell or taste may be very diversely interpreted by us, and that the same sensation will now be named as one thing and the next moment as another. Suppose an agreeable smell of flowers in a room: a visitor will notice it, seek to recognise what it is, and at last perceive more and more distinctly that it is the perfume of roses – until after all he discovers a bouquet of violets. Then suddenly he recognises the violet-smell, and wonders how he could possibly have hit upon the roses.

Just so it is with taste. Try some meat whose visible characteristics are disguised by the mode of cooking, and you will perhaps begin by taking it for venison, and end by being quite certain that it is venison, until you are told that it is mutton; whereupon you get distinctly the mutton flavour.

In this wise one may make a person taste or smell what one will, if one only makes sure that he shall conceive it beforehand as we wish, by saying to him: "Doesn't that taste just like, etc.?" or "Doesn't it smell just like, etc.?" One can cheat whole companies in this way; announce, for instance, at a meal, that the meat tastes "high", and almost every one who is not animated by a spirit of opposition will discover a flavour of putrescence which in reality is not there at all.

There is nobody who cannot personalise the above extract by substituting his own experience, Meyer's observations providing a template for all our palates, all our nostrils. Certainly neither taste nor smell is exempt when it comes to considering the power the imagination holds in falsifying the impressions made by the senses.

6 That Uncertain Feeling

It seems unjust that touch is always relegated beneath the other four senses and dismissed as "the fifth sense", particularly when it can be said to comprise five senses within itself, namely the mechanisms for registering pain, heat, cold and pressure, as well as physical contact with objects at the most basic level. The innermost working of the complex network of nerves that communicates signals to the brain from all parts of the body's surface, and the way in which we then interpret them as conscious feelings, are no more fully within our comprehension than a total understanding of the other sense organs. We do know, however, that our skin represents a protective suit studded with various sensory receptors or endings, which specialise in receiving different stimuli. This is where confusion begins.

The most common receptors, the first which we develop as babies, are the "free" nerve endings. These do not end in any specific shape and would appear capable of signalling each touch sensation, especially pressure and pain. The other principal kinds are classified under the umbrella title of "organised" nerve endings, each receptor ending in a distinctive structure or "end organ". Larger than their "free" counterparts, each is named after the researcher who discovered them. Most prominent are the oval-shaped Meissner corpuscles for signalling basic touch, the onion-layered Pacini corpuscles for deep pressure, the Ruffini corpuscles for detecting warmth, and the Krause end bulbs for cold. In no way, however, can these divisions be considered watertight. Research by others in correlating ending and sensation has proved conflicting. There is much evidence today to suggest that amongst the organised endings only the Pacinian corpuscles register anything beyond basic physical contact.

More secure is the area of research which bypasses the microscope and studies the varying degrees of sensitivity of different areas of the skin. Over the body as a whole, pain receptors predominate, with those which register touch, warmth, and cold decreasing successively in that order. This does not, however, preclude the fact that pain or touch is felt with less precision by one part of the body than another. That is the crux of our first test.

Body Trick 39

The denser the grouping of touch receptor endings packed together under a specific expanse of skin, the more sensitive that area will be in

detecting the exact nature of the touch stimulus. You can prove this by first prising apart a hairpin so that its points are about an inch apart. Gently press the prongs simultaneously against the back of a friend's forearm, where the touch-sensitive nerve endings are a considerable distance apart from one another. He will be unable to distinguish the two points of pressure; will feel, in fact, what appears to be a single point. However, bend the prongs inwards so that the gap between them is one sixteenth of an inch and this time place them together against his extended fingertip. Surprisingly, he will now have no difficulty in differentiating the two points and making out the space that exists between them. This is because the touch endings of the finger are that much more closely packed. Even more sensitive than the fingertips are the lips and the tip of the tongue. Here points as close as one thirty-second of an inch can be distinguished. On the other hand, the neck and the back are so insensitive that it is often difficult to distinguish two points as far as two and a half inches apart.

A fascinating variation of the above involves setting the prongs of the hairpin an inch apart and drawing them together, not too slowly, against the skin from the crease of the elbow down the forearm, and over the wrist, so that finally one prong reaches the tip of the second and the other the tip of the third finger. Throughout, the distance between the points must remain constant. What commences as a single sensation changes eerily into a double one, the distance between the prongs appearing to increase the closer you get to the fingertips. In the illustration the dotted line corresponds to the actual journey traced, the solid line to the sensation felt.

A similar sensation can be felt by drawing the prongs horizontally from below the ear across the face in two parallel lines, so that the mouth is sandwiched between them. What you will actually feel, however, is the pronounced shape of an ellipse that appears to fit around the lips snugly. This demonstrates best of all how the distance between two moving points not only appears to increase when they are drawn from a less sensitive to a more sensitive area, but also how they appear to converge on one another when that direction is reversed.

There are other ways of testing these variations in sensitivity. If you close your eyes and ask a friend to write large letters on the palm of your hand with a blunt pencil, you will be unable to distinguish all but the most simple outlines like X and O. Let him write in minute detail on your fingertips, however, and you should have no difficulty in telling apart those letters most often confused: a with d, n with h, s with z, for instance.

Again, bend some narrow strips of thin cardboard into simple geometrical shapes of different sizes—square, circle, triangle. Close your eyes and try to make out the shapes by pressing them against various parts of the body. You should, for example, be unable to tell the difference between a two-inch square and a triangle of equal size against your forearm.

Body Trick 40

It is possible to show that the same length or area of skin can convey a greater or lesser sensation depending upon the manner in which it is stimulated. With a pair of scissors carefully snip a saw-tooth pattern from corner to corner along one long edge of a visiting card.

Along the opposite edge cut out a complete gap all the way along between the two pointed corners.

Although the distance between the two farthest corners is the same on each side, if you now press the two edges in turn against, say, your forehead or your cheek, always the length between the two ends of the jagged side will feel closer together than that between the two corners separated by the extended gap. This presents an odd reversal of the optical illusion where two separate points exposed to the retina appear closer together than the two ends of a series of points or a complete line over the same distance.

A not dissimilar effect can be obtained by drawing a straight line on a sheet of paper. Mark the exact halfway point along the line and

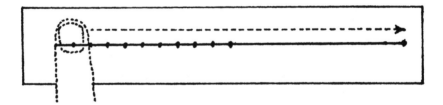

then with a pin puncture the line here, at both ends, and all the way along from one end to the centre. With your eyes closed, draw your finger against the lower side of the paper all the way along the line. The stimulus here is a gradual and changing one, unlike the visiting card effect where the complete length of one side is felt at once. Still, however, the length of the half-line which is free of perforations will seem longer than that which is studded with them.

Body Trick 41

Another strange facet of touch is that a warm object will feel lighter than a cold one. To test this, ask somebody to lie down and then place a cold coin on his forehead. After a while remove it and place a pile of two identical coins which have been moderately heated in its place. Curiously the two warmer ones will appear no heavier than the single cold coin.

There are several similar tests which prove that when two stimuli are experienced simultaneously or in quick succession, the sensations received affect each other in a way one could never envisage, experiencing them individually. In this way a heavier point moving across the skin appears to travel faster than a lighter one which is moving at the same speed. A set area of skin immersed in hot water gives the sensation of a certain temperature. Change the nature of the stimulus by increasing the amount of skin which you allow to come into contact with the water and, although the temperature remains constant, the water will appear that much hotter. In this way a hand will always feel warmer than a finger submerged in the same hot water.

Psychologists and physiologists will continue as long as the human body thrives to debate why ambiguities like these should occur. What they all know in their heart of hearts, however, is that the body is so complex that they have as much chance of resolving a simple, straightforward solution as they do of detecting the colour of a man's eyes by consulting his shadow.

Body Trick 42

Far easier to understand is touch's equivalent of the fatigue principle and its effect on the receptor cells which has already arisen in our studies of taste and vision.

You will need three glasses, one containing hot water, another iced water and the third either tepid or at room temperature. Insert one forefinger in the hot water and the other in the cold. After a minute or two, put them both together in the tepid glass. In spite of the fact that both fingers are now immersed in water of the same temperature, the water in that one glass will now feel cold to the finger that was originally held in the hot water, and hot to the one that was originally submerged in the cold.

Even though we know that this is an impossible situation, that water can no more be both hot and cold than a surface can be both rough and smooth, the brain supports the incorrect judgment of both hands and allows us to embrace the paradox.

Body Trick 43

One can be deluded into thinking that extreme cold is in fact extreme heat. A heat stimulus so intense that it will cause pain when brought into contact with the skin, will not too surprisingly have the same tactile effect as a similarly intense cold stimulus, the pain from both swamping the basic temperature sensation.

Take a piece of ice and with a knife shape one end until it matches the diameter of a cigarette. Dry the end. If you now apply that end quickly but firmly to the back of a person's neck in a group of smokers, making sure that the victim does not see what you have in your hand, his immediate reaction will be to suppose that you have rather callously burnt him with the lighted tip of a cigarette. Just as the size of the tins governed the weight we felt when they were lifted in the section on vision, so the victim registers subconsciously that the source of pain more likely in the present situation, namely a cigarette, is the guilty party.

Body Trick 44

Of all the paradoxes that revolve around temperature, the one that follows is the most tantalising. If cold water with a temperature of about five degrees centigrade is allowed to run through a plastic hose, that hose will feel cold to the touch. Likewise, if warm water of about forty degrees centigrade is channelled in a similar fashion, the hose will feel warm. However, intertwine two hoses together spirally in double helix fashion, continuing to let warm water run through one, cold through the other, and you will get a surprise. When you grasp the double coil with your hand you will receive the sensation of intense though illusory heat, a phenomenon which no theory can explain; unless we are to suppose that burning heat, in order to be experienced

as such, acts as a stimulus on both our warm and cold receptors, the double coil providing an eerie, artificial externalisation of this effect.

Body Trick 45

Rub the tip of your nose with the first and second fingers of your right hand and not unnaturally you will feel—the tip of your nose! The information imparted to the touch receptors on the inner side of the index finger and the adjoining side of the second, which is then transmitted to the brain, is there pieced together to form a mental image corresponding to the nose which we know. It is possible, however, to confuse this system with odd results. Cross those same two fingers and rub your nose again. This time you will feel two noses, the result of familiar stimuli travelling to the brain by strange paths! Not used to merging in our mind the impressions made on the opposite sides of the two fingers, namely their outer edges, we consequently find it difficult to register a single nose.

The first reference we have to this illusion is by the Ancient Greek philosopher Aristotle, in whose account a pebble-shaped object was used. Try rolling a large marble or pingpong ball between your crossed fingertips on a table and you will also feel two of each. You will obtain the best results if you roll the sphere in such a way that it touches first one finger and then the other in turn. It is also advisable to close your eyes while you do so. Then, if you truly want to make believe, there is nothing to tell you that you haven't two marbles at your fingertips.

You can try an amusing variation on a friend by showing him two marbles and asking him to close his eyes. You then guide his crossed fingers to rest on them, in actual fact placing them on one marble only and sneaking the other one into your pocket. Ask him how many he can feel. He will say "Two", whereupon you tell him to open his eyes. Watch his surprise when he sees only one. Of course, if you were to touch two marbles in this fashion, you would feel several!

Body Trick 46

Although related in principle to "Aristotle's illusion", the effect achieved by the following is vastly different; hence its separate treatment here. Extend your left index finger at the same time as you invite a friend to extend his right index finger. Clasp these two hands together, the two extended fingers, yours and his, touching each other

along their length. Now invite him to feel this double finger by running the finger and thumb of his free hand along it, the thumb touching one finger and the forefinger the other.

As you will find when you try it for yourself, this produces the weird sensation that half your own index finger has become numbed and devoid of feeling. The fact that what is really happening is staring you both in the face does nothing to diminish the tactile illusion.

Body Trick 47

This test also falls into the category of misleading sensory illusions. If you intertwine the fingers of both hands and request a friend to touch one finger, you will have no difficulty in wriggling that same finger. Confuse the system once again, however, by carrying out the following instructions and you will in all probability be frustrated.

With your arms outstretched, cross your wrists and then, still keeping them crossed, clasp your hands palm to palm with the fingers interlocked, as already suggested. Next, swing your hands down and inwards towards your body and then as upright as possible beneath the chin. Have someone touch a finger as before. As soon as you feel the touch, you must wriggle the finger. When you try to do so, you will almost certainly move the wrong finger, due to the difficulty experienced by the brain in sorting out which finger is which when the hands are in this unusual position.

A similar phenomenon occurs if you lie on your back with your arms stretched back behind your head. Suddenly objects whose size, shape and positions you assumed you were familiar with, take on a strange new identity when placed within reach of your hands. Again, have a friend turn his back on you while he keeps his arms extended at forty-five degrees to his sides. Then grasp his wrists and bring them slowly backwards towards you so that the backs of his hands are touching. Rub the backs of his hands together lightly and he will experience the curious sensation of his arms still being wide apart, in spite of the contact between his hands. Often people are hard to convince that their hands are touching at all.

Body Trick 48

The fake spirit mediums who proliferated in the early years of this century often included amongst their unscrupulous wiles the following experiment in "dematerialisation", which relies solely upon our susceptibility in certain circumstances to continue feeling something long after it has been removed from our body surface. You will need a disc of heavy cardboard with a hole seven inches in diameter in the centre. The brim of a stiff hat with the crown completely removed works even better. Your victim, who must promise to keep his eyes closed or else be blindfolded in such a way that he can see nothing, must be seated in front of you.

Take the disc and, exerting some pressure, place it on his head, removing it again immediately without telling him so. He will now continue to feel the disc around his skull for as long as you wish him to believe it is there! The mediums themselves would then hide the prop under their coats or the cushion of an adjacent chair and not draw attention to its disappearance until several manifestations later when they would ask the victim to reach up for it with his hand.

A burlesque of the initiation ceremony of the American religious sect, the Shakers, makes play of the same phenomenon. Somebody is asked to lean back in his chair, whereupon a slightly moistened coin is pressed firmly on the centre of his forehead in a position where he will be unable to see it by looking upwards. As in the earlier test, it is removed instantly without his knowledge. He is now told to shake the coin off his forehead without moving from his chair or touching it with his hands. His frustrated efforts to do so provide a hilarious travesty of the religious ecstasy with which the original Shakers are said to have trembled.

Body Trick 49

The following test is a natural extension of the preceding one. What makes this version so remarkable, however, is that here the phantom object "felt" is not an inanimate object like a cardboard disc or a coin but a real live human being. When I first encountered it in a classic magical textbook, *Greater Magic*, I was incredulous enough to dismiss it, until, that is, it was performed upon myself by Jay Marshall, the distinguished American magical entertainer. It is without doubt one of the most impressive examples of the way in which tricks can be played upon the senses.

In effect one person places his hands on the arm of another who is told to close his eyes. The latter is asked to state how many hands are on his arm. In reply, he is adamant that the two hands are there, although the performer has since removed one. When he uses this to take articles from the victim's pockets or to touch his person, the victim invariably imagines that a third party is involved.

Throughout the experiment success depends upon attention to detail. The person you choose as your victim should wear a coat, jacket or long sleeved dress. Assuming it is a man, position him on your right and ask him to extend his left arm in front of your chest.

Lift your hands palm downwards and, when they are level with his arm, bring them together and extend your left thumb in such a way that it is concealed beneath the right thumb. Now with both hands together you take hold of the victim's arm from above. Your left hand grips the flesh of the wrist that shows beneath his sleeve, the thumb being inserted under the sleeve, while your right hand holds the arm (and your left thumb) through his jacket. Do not exert too much pressure from your right hand, remembering that your left thumb is adding its own weight to what the victim feels is that of the right hand.

With your hands in position, instruct the subject to close his eyes.

Ask him how many hands he feels on his arm. He will reply, "Two". Tell him to open his eyes to verify the fact. Ask him to close his eyes a second time. As he does so, ever so slightly increase the pressure against his arm from your left thumb and simultaneously remove your right hand. Again ask, "How many hands?" Most people will swear that the answer is still two. Should he hesitate in his reply, you simply return the right hand to its former position exerting as little pressure as possible and have him check once more that there are indeed two. The third time around he will be as readily fooled as those who succumbed earlier. The opportunities henceforth for the use of the "third" hand you have mysteriously gained are limited only by your own sense of showmanship.

Body Trick 50

Had your victim not closed his eyes at the appropriate moment during the last test, his sense of touch would not have been deceived. This is not to say, however, that both senses coordinate with flawless accuracy even when the eyes are open. Recent experiments have shown that in instances where touch and vision present conflicting information, the latter sense completely dominates to the point where touch will adapt itself to erroneous visual information.

Irvin Rock and Jack Victor, two American psychologists, have devised an experiment in which the subject holds a small square of hard plastic beneath a cloth, while he looks through a reducing lens at the shape made by the square against the cloth. The nature of the lens is a secret, the cloth preventing him from seeing the reduced size of his hand which would of course give the game away. To test whether they were aware of seeing the outline of an object one size and feeling an object of another size, some subjects were asked to draw – an action involving both vision and touch – the exact size of the square, others to choose a matching square either by pointing to one of several squares of different sizes presented visually or by selecting one by touch alone while blindfolded. Although the easiest form of measurement is literally at one's fingertips, namely feeling the length of a finger against one side of the square, that held no meaning here. The majority of the subjects proved unaware that conflicting information had been presented. The square which they either sketched or paired most often corresponded to the reduced size of the square as seen through the lens, seldom to the actual size felt.

Further experiments have shown that vision continues to suppress touch in the perception of shape as much as size. When viewed through a cylindrical optical device that makes things appear narrower than they are, an exact square not only looks but also feels like a rectangle

with sides in the ratio of two to one. Close your eyes, however, and you will experience the bizarre sensation of the illusory rectangle actually changing to the square at your fingertips. In the same way, if you view a straight rod through prisms that make it appear curved and run your hand along the rod, the rod will actually feel curved.

One can have fun with a diversion not far removed from these effects by stretching about fifteen feet of cord in a straight line along the floor. Stand toe to heel with both feet on one end of the cord looking through the large end of a pair of binoculars at the same time. Then walk along the rope without stepping off. Although your sense of touch tells you your feet are securely on the ground, the reduced image seen through the binoculars overpowers that information. It comes close to feeling, in fact, as if you are actually walking along a tightrope.

Body Trick 51

Given the tendency for vision to override touch when their respective stimuli contradict each other, it's not unnatural to ask what happens to touch when the visual stimulus is seen to contradict itself.

Richard Gregory, in his investigation of the visual ambiguity of figures like the Necker cube, the depth of which, as we have seen, appears to change orientation of its own accord, constructed a three-dimensional wire model, four inches square, which he subsequently coated in luminous paint so that it would glow in isolation in the dark. The cube was then fastened firmly by one corner to a table surface.

Look at the wire frame in the dark and you perceive the Necker effect, the depth of the cube reversing spontaneously. In the context of this section, however, the obvious question to ask is what happens when one touches the cube at the same time as one observes it?

Touch by itself should and does signal the true state of the cube to the brain, but this does not prevent the visual reversals from occurring, even though they are now only half as frequent. It could be said that vision still gets the better of touch, but the true result is a paradox with normality alternating with the strange sensation of feeling the sides of the cube in one place while you see them in another. The way the visual and tactile worlds separate is an uncanny experience. One can begin to imagine how the young girl and the old crone in Boring's illusion would themselves feel, if it were possible to bring them to life.

7 Sleight Of Hand

In the world of the stage magician the hand stands paramount both as the symbol and the means of dexterity. In our own magic world of the body we find this supremacy maintained, the amount of nervous tissue in the brain responsible for controlling the muscular movements of the hand surpassing that devoted to any other part of the anatomy.

The human hand and brain grew up together; as the volume of grey matter increased to the point where it doubled in size with the evolution of man from "australopithecus" through "erectus" to "sapiens", so man found himself devoting this excess mental energy to manual activity. Hands, at last freed from all locomotive or walking responsibility, now found themselves learning to make weapons and tools, kill prey, cook food and paint caves.

As an instrument the hand is structurally more sophisticated than any other part of the body. Each one contains no less than twenty-seven bones, eight in the wrist, five in the palm, fourteen in the fingers, making in both hands a total of fifty-four, which amounts to more than a quarter of the bones in the entire anatomy. Each bone is connected to a tendon which power-drives the muscle anchored in the forearm responsible for moving it. Each act carried out by the hand is the end product of thousands of messages being sent from the brain, telling this tendon to pull, that one to give, this muscle to contract, that one to relax.

The fact that we never complain of tired hands only serves to emphasise how much we tend to take these mechanics for granted, until, that is, disaster strikes in the spectre of a burnt finger or a broken thumb. It is possible, however, to get to know something both of their working and their limitations at the same time as we keep both wonder intact and injury at bay.

Body Trick 52

It would appear to be the easiest thing in the world to hold a simple wooden match across the back of the middle finger, near the top, and beneath the index and third fingers of one hand and then, keeping the palm and fingers straight, to break it by pressing upwards with the middle one or downwards with the other two. If you do succeed, however, you will be in a very specialised minority.

Your surprise at your frustration becomes easier to understand when you consider the nature of the lever system which the muscles

responsible for moving the fingers comprise. Technically it belongs to the third order of such things in which the force or effort applied (at the point where the muscle is attached to the fingers) is situated between the fulcrum (the base of the fingers) and the weight or force resisted or acted upon (namely the match). Things like tweezers and sugar tongs fall into this same category.

In a lever of this kind you experience a considerable relative loss in power at the weight end, the price we have to pay for the enhanced mobility of the fingertips. This is true of the arms and legs as well as of individual fingers, their capacity for movement having proved more important in man's struggle for survival than their relative strength. The larger the ratio that exists between the distance from fulcrum to effort and the distance from fulcrum to weight, the smaller the mechanical advantage of the lever becomes. Therefore the further you move the match away from the fingertip towards the muscle point, the less difficulty you will have in causing it to snap.

Body Trick 53

Bring your two hands together so that the corresponding fingers and thumbs meet tip to tip, with the exception of the middle fingers of each hand, which should bend inwards towards the palm and touch each other along the back of the second bone or phalanx from the tip. With the hands in this position it is easy to separate the tips of either the thumbs, the index fingers or the little fingers, without in any way disturbing the contact achieved by other parts of the hand. When you attempt to separate the tips of the ring fingers, however, you will find them impossible to move without upsetting the rest of the arrangement.

A popular way of presenting this little known fact is to ask a friend to hold his hands so and to insert a coin between the two third digits. You then challenge him to drop the coin without separating his other

fingers. Of course, when he tries, he finds his hands inextricably locked together.

The experience shows how little importance we place on the ring finger, the least developed muscularly of all five digits, largely dependent, as a result, on the two fingers on either side of it. Change the position of the fingers so that now the middle ones are tip to tip, the little ones bent in towards the palm, and it is still impossible to move the third fingers apart. However, hold the hands together with all five fingers touching each other, both the middle and little digits released from their restricting positions, and you will find that you can now freely move the ring fingers apart without upsetting the other four pairs.

The above helps to explain why so many people have difficulty in separating their closed fingers so that a V appears spontaneously between the middle finger on one side and the ring finger on the other, both pairs of digits remaining close together on either side of the gap.

Body Trick 54

If the ring finger goes to the bottom of the digital class, the thumb must be awarded first prize. If we lost any one of the four fingers we

would still get by, but to lose the thumb would incapacitate us for almost fifty per cent of the work we do by hand. His skilled use of the thumb makes man unique among mammals; its ability to oppose the tips of the other four fingers with precision produces a combination of grip and sensitivity denied other creatures. To refer back to the importance of the brain in relation to the hand, as stated in the introduction to this section, the grey matter responsible for controlling this one small extension of the hand alone surpasses that set aside for overseeing both the abdomen and the chest together.

One can demonstrate this dependence on the thumb by strapping it to the palm with strong adhesive tape. Now go out of your way to try all those actions we tend to take for granted like picking up a pencil, writing with that pencil, lifting a glass, fork, or spoon, tuning into a radio station, threading a needle, even shaking hands. You cannot fail to be surprised at the difficulties that now present themselves.

Short of injury and artificial means, it is far more difficult to incapacitate the thumb naturally in the way that we tricked the ring finger above. There is a way, however. Curl your right thumb deep into the centre of your palm and then, with the hand in this position, touch the tips of the right fingers to the hollow of your right armpit, the elbow sticking out sideways. Alternatively, you could also touch the edge of your shoulder with the thumb in the same position. Either way you will find it easy to remove the thumb from the palm position but extremely difficult to replace it where it was before, without relinquishing finger contact. The sharp pain you feel shoot up your wrist as a result of your efforts is proof of the extreme sensitivity of the wrist muscles upon which the thumb to a large part depends for its flexibility.

Body Trick 55

When we speak of coordination in the context of the body, we mean the intricate interplay between the muscles and joints in our limbs and the nervous tissue in the brain that controls them. As we perform various tasks more frequently so we amass a store of conditioned reflexes between the two that tell us how to move this hand, that foot to produce a desired effect, whether it is driving a car, playing a piano or juggling an avalanche of Indian clubs in the air all at the same time. The more we repeat the task, the easier it becomes, until it passes into our subconscious where in effect we no longer have to think about it when we do it.

Because the habit becomes so ingrained, few people appreciate the amount of coordination actually required for even the simplest task, the

number of single messages that have to be transmitted from the brain for it to take place. Maybe some indication can be given by contriving a situation whereby our expertise with the simplest action theoretically becomes undone. That is the idea of the tests that follow.

Start by holding your two hands in front of your body with their forefingers pointing at each other. The rest of the fingers should be closed. It is now an easy matter to move one forefinger or the other in either a clockwise or an anti-clockwise direction, thus outlining a circle in a plane perpendicular to your chest. What is difficult, however, is to describe two circles simultaneously, one with each hand, each circle rotating in the opposite direction to the other. You will find that your coordination, more than able to deal with the preliminary part of the test, now goes completely berserk. Suddenly the brain has too much to cope with and finds itself, nominally speaking, back at that infantile stage when even the single circle was too great a challenge.

Refer back to the last paragraph of the second experience. If you were able with practice to separate the fingers into a V shape between the middle and ring fingers, you could try this. Hold one hand level in front of you, palm downwards, with the gap as described. Hold the other hand alongside it with two gaps, one between the index and middle fingers, and the other between the ring and little fingers. You now have, as it were, to change hands, moving the fingers of both simultaneously so that the hand with the single V becomes the one with the double V and vice versa. It is easy enough to pass from one position to another with one hand, bringing the fingers together and then opening them in the new arrangement. However, you can be the best coordinated person in the world and still find it a challenge to adjust the two hands together simultaneously in the way set down.

Body Trick 56

The dependence of the hand on the eye for guidance in performing simple everyday tasks is shown by the following amusing test. Like a time-machine it should whisk you back to childhood to experience once again the difficulties we all undergo, when very young, in coordinating the hand and the eye.

Find a mirror and stand it upright facing you on a suitable writing surface. In front of it place a sheet of paper. Now, holding a newspaper or magazine in your left hand (right, if you are left-handed) so that it hides the paper from your direct view, but not its mirror reflection, attempt with your right hand to draw a square on the paper relying only on the mirror for visual guidance. This should not prove too difficult; but when you then attempt to draw in the diagonals from corner to corner you might as well be trying to catch bubbles.

All those years of accumulated experience at doodling and sketching to the point where they become second nature here become shattered. The habit which makes for coordination in our normal experience now rebels in the looking-glass world against every move we make. The more intricate the design we wish to draw, the more chaotic the draughtsmanship will become. Even when you draw the design properly beforehand, then attempt merely to trace its outline with the point of a pencil by observing its mirror reflection, you will still meet more difficulty than you would suppose. If you were to persist, however, in writing and drawing in this distorted way, you would in time acquire a new coordination of eye and hand which would undo the ingrained habits of a lifetime.

Body Trick 57

Few people realise the actual depth of the hollow in the palm of their hands, a dimension which makes possible a simple, but surprising impossibility. You place a small coin on your outstretched palm and challenge anybody to remove it by brushing it off with a clothes brush. You can even suggest that, should they dislodge it, they can keep the money as a reward.

Your coin should remain safe. As long as people apply a true brushing movement with fair straight sweeps, the money will not budge, the bristles simply riding over the coin without touching it. Most brushes are too wide to extend into the hollow of the palm where the coin nestles securely, thus restricting contact to the raised skin around the outside of the palm.

Body Trick 58

Few myths in magic carry greater potency than the one which asserts that the quickness of the hand deceives the eye. It has been estimated, however, that in reading a book the eye muscles make at least sixteen hundred adjustments in one minute. No magician could ever hope to beat the speed with which they continuously shift the focal point from one position to another. The more rapid an action is, in fact, the greater the likelihood that it will draw itself to the attention of a vigilant audience unless it is disguised by subtle misdirection.

Nothing demonstrates this more effectively than the sleight which magicians call the paddle move, during the execution of which one small movement is rendered completely invisible under the cover of a larger one. The easiest way to familiarise yourself with the manoeuvre is to hold a slender table knife by the handle at right angles to the fingers

between the fingers below and the thumb on top. There are now two ways in which you can display the side of the blade which faces away from you. You can roll the fingers and thumb in opposite directions in a line at right angles to the knife, causing the latter to revolve by 180 degrees. Alternatively, you can turn your hand over completely by bending at the wrist, keeping the thumb and fingers in exactly the same position in relationship to the knife. Either way you reveal the other side of the blade. If you now combine these two actions, performing them at precisely the same time, not only will they cancel each other out, as it were, showing at the end of the double turnover movement the side of the blade which faced you in the beginning, but, if the movements are performed correctly, the smaller one between the thumb and fingers will prove to be indetectible under the cover of the wider sweep of the hand from the wrist.

The purpose of the sleight, namely to keep the audience from seeing marks on the other side of the blade until they are made to appear magically, is less important than the general principle which, because of the way they are built, we can apply directly to the hands themselves. Both the following exercises produce a seemingly magical effect which is dependent upon a smaller movement being disguised by a more expansive wrist action. In the first you convey the impression that you have one finger missing from your right hand; in the second that you have nails on both sides of your hands.

Begin by holding your right hand in front of you, palm towards the floor with the second finger tucked towards the palm from the centre

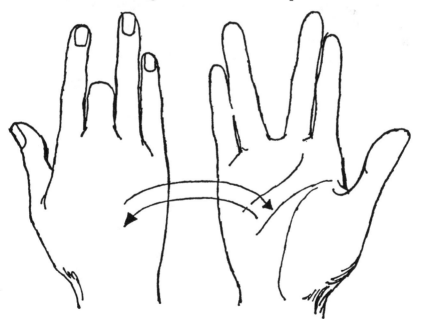

joint. Now revolve your hand through 180 degrees at the wrist, bringing your palm uppermost, but, as you do so, straighten out the bent finger and simultaneously open the hand to form the now familiar V position between this finger and the third. Then reverse these movements and continue by showing the back and front of the hand several times without pause. It is surprising how effective the illusion of the missing digit can become once both moves are properly synchronised.

For the second effect, clasp your two hands together palm to palm, with the fingers interlocked. Holding them both in front of you with the right hand uppermost, extend the fingers of this hand at length, still keeping the other hand firmly clasped. You should now be able to see all ten fingernails at the same time. To create the illusion of fingernails on both sides of the hands, you simply unclasp the left hand fingers and clasp the right hand ones under cover of turning both wrists through 180 degrees. Of course, you can also vary the above to show that you possess no nails at all on either side of your fingers.

8 Tricks For The Memory

This is not the place to enter the long-established debate about the exact physical structure of memory. Study of the intricate labyrinth of interconnecting nerve cells that constitutes the brain, the organ in which our powers of memory reside, has prompted a similarly complex tangle of theories, straddling both the chemical and electrical fields. It would seem safe to say, however, that external stimuli are transferred in the form of electrical impulses, via the senses and the nervous system, to the brain cells in which they produce grooves or memory traces. The more often the stimulus is repeated and/or the greater the vividness of the stimulus, the deeper the groove becomes and the more securely the memory of that stimulus holds. Of greater relevance to our theme, however, is the astonishing way in which the average person can, with no difficulty, train his memory to perform beyond the wildest imaginings of his normally forgetful self.

Psychologists with a flair for statistics have gone on record saying that the storage capacity of the average brain is large enough for ten new facts to be accepted by it every second. Even more amazing is the fact that once a piece of information has been stored away it is rarely forgotten. Experiments with people under hypnosis have shown how in such a condition one can recall information that could have been registered only subconsciously many years before, information as trivial as the number of steps in a flight of stairs climbed only once or the condition of the weather on an arbitrarily chosen date. "Never to forget", however, is not the same as "to remember". In a normal state of consciousness the difficulty is in recalling at random the appropriate fact from the vast depths of our mental archives. The key to such retrieval is association.

You have only to say the word "play" and instantly a profusion of memories and associated ideas will rush to mind: children at play, playing cards, *Playboy* magazine, playbills, playing the devil, pianos, baseball, cricket, fast and loose. The stream is endless. Had the word "play" not presented itself to you, it is doubtful if you would have recalled in the same context concepts as diverse as musical instruments and Satan. It appears likely that anything we wish to recall must be associated in some way, however fancifully, with something already remembered or prompted by some other source. All our knowledge, in fact, represents one massively interconnected organism, our own personal model of the Universe within the skull. This is the basis upon which much memory training and all so-called mnemonic (after the Greek goddess of memory, "Mnemosyne") technique thrives. In

mnemonics the association is, as we shall see, force-fed. Often, however, the name you wish to recall will suddenly leap at you from out of the blue without your being aware of any conscious form of association taking place, a procedure that suggests that it is possible for a search to be made of our memory store subconsciously without our being aware of the process involved.

In various academic quarters mnemonic systems have acquired an unfair reputation for being too cold, systematic and robot-like. Paradoxically, however, while their main purpose *is* to impose system on an otherwise random mass of information, in order for them to work with greatest effect it is essential to possess a mind that is, above all else, flexible and imaginative. The more bizarre and unusual the mental picture weaved around the information to be remembered, the stronger the particular memory trace for that information becomes, and the more easily it can be recalled. Imagination, humour, dreaming potential, even sexuality, all enhance the memory process. Consequently the more you rely upon these faculties, the more they themselves are trained as a bonus in the process.

Body Trick 59

An effective way of demonstrating the importance of association to memory recall is to present half the people at a party with the list below on the left and the other half with that on the right. Give them sufficient time to read each word to themselves and then, with the information hidden from view, get them to write down as many words as they can recall in a given time limit.

List One	List Two
snake	*book*
violin	*worm*
target	*snake*
terrace	*skin*
skin	*nude*
arrow	*violin*
book	*bow*
football	*arrow*
worm	*target*
nude	*goal*
goal	*football*
bow	*terrace*

If you look carefully, you will see that both lists contain the same dozen words in a different order. However, when the results are

compared, those who were given the right-hand list will be seen to have scored more highly than those who studied the left, simply because the second list was compiled in such a way that each word has some natural association with the word that precedes it. On the other hand, the order of the first list was made completely at random, with no conscious attempt at establishing a relationship between adjacent items. We absorb more information when it is presented to us in a form or context that is already familiar; that is why the second list is so much easier to remember.

Body Trick 60

Many mnemonic techniques depend upon associating new information with something that is already committed to memory. As far back as 500 B.C. the Greek lyric poet Simonides was credited with the earliest known application of this principle. The legend tells how one day he was called away from a banquet at which he was performing. During his absence the roof of the building collapsed killing all the guests. It was impossible even for relatives to identify the mangled corpses, until Simonides found that by first recalling an image of the table around which they had been dining, he could then easily connect each seat with its occupant.

It is possible to translate this same method into your own experience by mapping out in your mind a fixed tour of your home. When next presented with a random list of objects to remember, you simply visualise each item at a successive spot in the domestic journey: on the stairs, on the landing, in the bath, and so on. To recall the information, simply resume your mental excursion from its starting point and the items will suggest themselves automatically, triggered off by association with their imaginary positions.

Simonides' discovery was eventually formalised as part of the standard training for Greek rhetoricians who were expected to memorise an abundance of argument and evidence by heart. The main points of their speech, translated into material images, would then be deposited mentally in the appropriate rooms, alcoves, corners and stairways already imprinted on their memory. The technical term for these points became "loci" or "places", suggesting maybe an origin for that speaker's cliché, "In the first place . . ."

In his book, *The Mind of a Mnemonist*, the Russian psychologist, Professor A. R. Luria, describes how, in order to remember a long list of objects, his subject, a Russian journalist referred to throughout as S, would take an imaginary walk starting at Moscow's Mayakovsky Square and proceeding along Gorky Street, visualising each object at various positions along the route, in gateways and shop windows, by pillars and

doors. To recall the information, he would simply repeat the imaginary stroll. Ironically, the only time he made an error was when he deposited an image in a badly-lit place, the lack of light causing him to walk past it on his mental journey.

Body Trick 61

During the Middle Ages and the Renaissance the planets and signs of the Zodiac were both used in learned circles to provide a system of such "loci" for memory purposes. Nowadays the series most universally used, however, is the one which we all know without having to make any special mental effect, namely the numerical system. There are various ways in which one can adapt the latter to lend itself readily to vivid association with the items to be remembered. One depends on first rhyming the numbers with objects which will provide the "loci": gun, shoe, tree, door, hive, sticks, heaven, gate, line, pen and so on. Another relies on a visual similarity between the digits and your basic list:

1	:	*Candle*
2	:	*Swan*
3	:	*Pawnbroker's sign (three brass balls)*
4	:	*Sail*
5	:	*Hand (five fingers)*
6	:	*Elephant's trunk (appropriately curled)*
7	:	*Bow of a ship*
8	:	*Hour glass*
9	:	*Pipe*
10	:	*Bat and Ball*

If you wish to extend the system beyond ten, analogies other than visual ones can be applied:

11	:	*Pair of legs*
12	:	*Midnight*
13	:	*Ladder (walking under one is also unlucky)*
14	:	*Courting (rhyme)*
15	:	*Lifting (rhyme)*
16	:	*Honey (sweet sixteen)*
17	:	*"Cannot be seen" (rhyme)*
18	:	*Baiting (rhyme)*
19	:	*Pining (rhyme)*
20	:	*Sentry (rhyme)*

It is always advisable for the individual to compile his own personal

master list. When you have prepared yours, make sure you commit it to memory for ever and can recall it without the slightest degree of hesitation. You will then be able to memorise a list of any twenty objects presented to you at any time.

To work the system, you must make some way-out, bizarre (the more so, the better) association between the first object to be remembered and its corresponding key word. For example, if the first object is a tube of toothpaste, you might picture a gun (the key word for one in the first suggested list) oozing toothpaste from its barrel when the trigger is pulled. If the second is a tea-cosy, you could picture a swan (the key word for two in the second list) gliding past on the water wearing this absurd costume. When all the objects have been given and all your associations formed, by recalling the key words to yourself you will be able to recite the entire list of items backwards or forwards with no difficulty at all. Moreover, someone can volunteer a number and you can instantly give the name of the object at that position in the list. Alternatively, he can name an object and you can give him its numerical position in the sequence. Perhaps even more amazing, however, is that next time around, when you attempt to remember a further twenty objects by the same system, the very process will eliminate all trace of the previous items committed to memory. The brain automatically adjusts in such a way that there is no danger of confusion as a result of two objects being triggered off by the same key word at any one time.

The capacity of the mind for making and retaining vivid associations was shown in an experiment carried out about ten years ago at the University of Pennsylvania. The subjects were given cards on which were printed two otherwise unrelated words. They were asked to form some mental image that would connect the two. Two or three days later, when presented with only one of the words on a card, they could almost always name its partner. The process was found so easy that the original list of twenty-five pairs soon progressed to 700, and ceased only out of eventual boredom on the part of those involved.

One can adapt the above idea to an impressive memory demonstration, first suggested by Al Baker, the prolific American inventor of magical methods. The more people present, the more impressive the feat will appear. Each person calls out his initials, together with the name of an object of his choice. These are recorded by the performer, who hands the completed list to a member of the audience. As soon as the spectator calls out a set of initials, you can name the appropriate object or vice versa.

As soon as you hear the initials of a spectator you convert them into some vivid short word or phrase that will remind you of them. This is then associated with the object volunteered by the same person. Let us assume that the first person shared the author's initials, J.F. You might think of "jelly fish". Let us assume that the same spectator suggested

the object "fork". As you write down the word, just connect the two in a simple sentence: "Fork fails to spear jelly fish on plate". That is all you have to do. It works from there.

Body Trick 62

Ask an intelligent person merely to glance at the word "indecipherability" for only a couple of seconds and he will be able to spell its seventeen letters back to you from memory, because they relate to certain patterns of association firmly established in the mind. Substitute the figures 62139743097814316 in place of the word and the task of recalling them becomes far more time-consuming for the simple reason that there is no apparent method in their order. Hence that branch of mnemonics that teaches how to remember figures by translating them into words.

Again one has to remember a key code in the form of a number alphabet, the consonants distributed according to their specific relationship with the digits for which they stand:

1	:	l,t,d	(single downward stroke)
2	:	n	(two strokes)
3	:	m	(three strokes)
4	:	r	(last letter of "four")
5	:	f	(first letter of "five")
6	:	b	(resembles digit)
7	:	v	(resembles digit, when turned on side)
8	:	g	(appears only in spelling of "eight")
9	:	p	(resembles digit, in mirror image)
10	:	s or z	(for "zero")

Let us suppose that you now wish to remember an eight-digit telephone number, 45623195. It is always advisable to divide the figures into pairs before translating them into letters: 45–62–31–95. You now set out to translate the pairs into words by inserting vowels between the consonants as follows: RooF; BuN; MaT; PufF. In order to be able to recall this particular number you then make a visual picture incorporating the code words in story form. Visualise the sloping roof of a house. A bun rolls down and falls on to the mat, whereupon it disappears in a puff of smoke.

In this way you will be able to associate dates and telephone numbers with people, flight numbers with destinations, population figures with countries, as well as to show off purely for entertainment purposes. Not all of the consonants have been used above, but there is no reason why the surplus ones cannot be given their own place in the

system. For some people K works in addition to m for three, in that it also comprises three strokes; W likewise doubles for r for four, with its four strokes. Obviously the more letters you use the more flexible your system becomes, because you will be able to formulate words more easily. As in the previous tests, it is advisable for everybody to devise their own codes.

Body Trick 63

The distinguished New York mnemonic expert, Harry Lorayne, a showman who makes memory demonstration as exciting an entertainment today as Houdini once made escapology, insists upon being introduced to each member of his audience before he presents his act or lecture. Then as a climax to the performance he asks each person present to stand and not to sit down again until he has given them their surname. I once saw him account for a television audience of no less than 200 people in this fashion in no more than seven minutes. In addition, he interpolated incidental details such as Christian names, relationships and changes of seat position and clothing at the same time. In fact only time and the size of the theatre set a limit on the size of audience he can enthrall at this very personal level.

The methods used by Lorayne can be adapted by all of us as a face-saving device to forestall those embarrassing moments when we find ourselves unable to put a name to a familiar face. The crux of the matter is once again association. Having translated the name into as vivid a mental image as possible, you connect it in your mind with the most outstanding feature of that person's physical appearance. The latter may be a blemish like a spot, an idiosyncratic hairstyle, an odd-shaped nose, chin or other feature, or even a fleeting resemblance to a famous person.

The most likely difficulty is that the surname itself, particularly if it is a foreign word, will not instantly suggest a concrete image. Names like Brown, Fox, Hill, Piper, Taylor, Webb, have immediate meaning and present no such problem. Some less straightforward names, like Chaplin, Einstein, Monroe, Thurber, are helped by the images we associate with the famous people who have lent prestige to them. Consider, however, names like Cohen, Gordon, Dahlstrom, Falkenstein, and Romanovich. Here your mind has to become flexible. It should not be too difficult to convert them into intelligible images, even though you may have to break them down into component parts in the process. If the single image of an ice-cream cone fails to satisfy for Cohen, perhaps the more fanciful idea of a hybrid between a cow and a hen will. Gordon might suggest a garden or the Gordian knot. Dahlstrom can be split into doll and strum, so picture a doll strumming

a guitar. Similarly, Falkenstein can imply an image of a fork in a stein or tall beer mug and Romanovich a witch on her broomstick wearing a Roman toga.

Having converted the name into an image, you should have no difficulty in connecting it to the most salient physical characteristic of the person involved. Maybe Mr. Cohen has a high forehead: visualise an ice-cream cone projecting from it like a unicorn's horn. Maybe Mrs. Romanovich has a huge nose: picture your toga-clad witch riding the bridge of the nose rather than a conventional broomstick. Maybe Miss Gordon has a bouffant hairstyle: imagine it to be the luxuriant lawn of a garden embedded with flowers and shrubs. The possibilities are endless, while the process is at once entertaining and rewarding. Practice, of course, makes perfect, but you will be surprised how little time it takes for the system to work.

Body Trick 64

Vaudeville mind-readers have long used a combination of the fixed-list association principle and the chain method of linking items to be remembered in their own fantastic story sequence, to produce a truly staggering impression of mental telepathy. To carry full effect the test should be attempted with at least five people, but, to safeguard against boredom on the part of the spectators, no more than seven. In the description that follows we shall assume five to be the working number. Once the basic idea is understood, however, it is easy to adapt to groups of different size. You will also need a pencil, a hat or suitable container, and some slips of paper.

Mentally number from one to five the people whose help you are going to enlist. Approach the first person and ask him to call out the names of any five objects at random. You write them on a piece of paper which you hand to the spectator with the request that he simply thinks of and remembers one of his words. When he has done so, you tear the paper into five slips so that each piece contains a word and then, folding them over a couple of times, drop them into the hat. The same procedure is repeated with the other four participants.

While this takes place, you must, unbeknown to the audience, secretly remember all five words of each individual. For this you will need a basic peg list to cover the number of people involved – say, one: gun; two:shoe; three:tree; four:door; five:hive. As you jot down the words of the first participant, associate "gun" with the first word he gives you and then continue to link the others in a continuous chain of association, the more absurd and imaginative the better. In similar fashion, the second spectator's chain will begin with "shoe", the third's with "tree", and so on. Once all the information required is neatly

compartmentalised in your brain, you can then attempt your mind-reading feat.

Ask somebody to hand you any five slips from the hat. Unfolding them one at a time, you read out the five words written on them. You then ask those who have just heard the one word they eventually chose called out to put up their hand. Sometimes no hands are raised, in which case you proceed to the next five slips. When a hand is raised, however, you can instantly tell that person the word he has been thinking of. This is then repeated with another five slips, and another five until all five chosen words have been divined. At least, that is what the audience imagines takes place. In fact, you do *not* read out the words on the slips in your hands. When you take the first five pieces of paper you ignore the words written on them and, referring to your mnemonic system, actually pretend to read out the first word from the first spectator's list, the first word from the second spectator's, and so on. Whoever raises a hand, you know instantly his word within the five. If the first spectator puts up his hand, then the first word called by you must be his. When you progress to the next five slips, you simply call out the second word in each person's list. The process of identifying a raised hand with a spoken word remains the same. What makes the mystery so effective is that nobody ever imagines that you could, let alone would, memorise all 25 words so quickly. Consequently, their headlong rush for an explanation leads them to consider powers much deeper and far more mysterious.

9 Thoughts That Go Bump In The Night

The fact that every conscious action we perform is controlled to some degree by the mind should not need stating. On the other hand, that a thought or idea fixed in the mind can manifest itself in the form of concrete physical activity, without any conscious attempt at movement on the part of the person involved, is less obvious. The accepted psychological term for such physical reaction to thought is ideomotor response. It would appear that the tiny rhythmic variations in the electrical charges within the brain which are responsible for the thought process cannot stop there, but transmit themselves via the nervous system to the muscles where, as we shall see, the resultant tensions and relaxations can produce surprising effects.

The more intently the thought process is directed towards a specific part of the anatomy itself, the more one becomes aware of the physical effects of the phenomenon. Concentrate hard on your toes, for example, and the likelihood is that either they will begin to wriggle slightly or that you will find yourself suppressing a strong desire to wriggle them. Without realising it, many people move their lips slightly when reading silently to themselves. The polygraph or lie detector is based on the same principle: a machine that can interpret the actual thought process from the slightest physical movement in spite of what its victim might say in contradiction of the results.

Perhaps the most fascinating aspect of the phenomenon is what Ormond McGill, the American magician, referred to as the "law of reversed effort". He deserves quoting in full:

> In all such demonstrations utilizing ideomotor response, the amazing part of the experiment is that the actual creators of the motivating force have no idea that they are the cause. In fact, they often strive most sincerely not to make any movements that would assist the effect, but in this the so-called "law of reversed effort" comes into play and the more effort they put forth not to impart movement, the more unconscious movement they actually produce. As long as the assisting spectators conscientiously concentrate upon your directions towards the production of a desired manifestation, the manifestation will occur.

In this section we shall see how specific instruments and objects can be placed under the control of these involuntary muscular movements, possibly exploding in the process many of the myths of Victorian spiritualism and the occult such as water-divining, table-tilting, and the

ouija board. In the next we shall discover how the skilled interpretation of the cues provided by the same involuntary movements in others can produce the closest approximation to telepathy acceptable to rational man.

Body Trick 65

Study of the ideomotor response enables light to be shed on the ancient mystery of dowsing or water-divining, exponents of which claim to possess the occult power of detecting the proximity of underground currents of water as well as of veins of metal by means of the twitching of a forked twig held between their hands.

In more recent times the wooden twig has been superseded by a pair of L-shaped metal rods which can be fashioned quite easily from standard wire coat-hangers. With a pair of wire-cutters snap off the top hooked stem from one coat-hanger, leaving an isosceles triangle with a gap at the apex. Then cut off one of the two shorter sides. Adjust the angle in the bend of the remaining piece of metal until it reaches ninety degrees. Then shorten the shorter stroke of the L so that it measures no more than five inches. This constitutes one rod. Prepare a second one in exactly the same manner. The short ends provide the handles which should be held in the fists, the longer lengths extending parallel to each other about twelve inches directly in front of you at chest level horizontal with the ground. Your forearms will be extended forward from the elbows. The idea is that when the successful dowser walks out over an expanse of uncharted land with the rods held steadily, but not tight, in this position, they will uncannily swing inwards towards each other when held over a spot where water or mineral deposits are situated.

That the moving force is the ideomotor principle can be proved by a variation of a simple magic trick with several tea-cups or tin cans and a rolled-up treasury note or bill to which is secretly attached a fine thread best teased out of a dark nylon stocking. If someone now hides the money beneath one of the cups while your back is turned, you will later be able to detect its position thanks to the tell-tale thread. If you now hold the rods as described in turn over each cup and merely concentrate on the idea of them swinging together when you reach the one concealing the money, they will pull themselves in towards each other without any apparent or conscious physical motivation on your part. You may have to experiment with the correct hold of the rods. You should aim at a light touch, a compromise between grip and balance, whereby they are just restrained from swinging inwards until the ideomotor mechanism tells them to.

The success of the professional dowser, however, would suggest that

the prevailing idea upon which the ideomotor response relies for its existence need not be a conscious one. In bona-fide cases where the operator genuinely appears to locate water with the rods alone, presumably it is his subconscious mind that must send the necessary information to the appropriate nerves and muscles in his arms, wrists and hands.

He must "know" somehow, knowledge itself being the mental trigger to the whole ideomotor phenomenon. Not surprisingly some of the most successful operators have been people familiar with the ground over which they have walked or possessing a geologist's experience of land formation in relation to moisture or metallic deposits. The honest dowser, however, need not be aware that the particular appearance, sound or smell of the terrain has influenced him. It·is accepted that all sensory stimuli have to reach a certain intensity before they can enter consciousness. However, there exists a border area where such stimuli can affect one subconsciously and it does not seem unreasonable to suppose that sensory activity at such a level is that much more prolific in the case of the dowser. Subconsciously his brain is able to interpret the clues picked up by such an acute sensitivity – scarcely perceptible vapours, say, or subtle changes in soil colour or vegetation – and is thus able to indicate the spot for him. Of course the expectation of the ideomotor effect itself – namely the desire for the rods to swing – must be present at all times in the dowser's mind. It is through the combination of his innate physiology and the divining fork or rods that the knowledge he seeks is able to gain entry into his consciousness.

At a recent dowsers' convention in Danville, Vermont, one operator claimed that he could throw fork and rods away and still dowse with his neck and back, the rod with which nature herself had endowed him. With his body stiff as a board, he demonstrated on stage what he described as his "rigid spine" state. Brought close to water his whole body vibrates or, to use his word, "activates". On the other hand, there are sceptics who claim that dowsing is the most widespread example of mass self-delusion in the history of civilisation. Between the two extremes there lies a route signposted by sound biological principles, the only fault of which is that they divest the phenomenon of the occult mystique it has acquired from earliest times, when bas-reliefs in Ancient Egypt depicted exotic characters in unusual headgear carrying even stranger objects at arm's length in front of them.

Body Trick 66

Even more famous than the divining rod as a means of externalising minute muscular movements made independently of one's conscious physical motivation is the pendulum. In its most common and accessible

form, it consists of a finger ring suspended securely on a length of thread no more than twelve inches long.

The most widespread and comical myth connected with it is that it is capable of detecting the sex of unhatched eggs. It is said that if a pendulum is held over an egg and swings in a straight line, the chick to be hatched will be male. Alternatively, if it swings in a circle, the chick will be female. It so happens that when held over the palm of a man the pendulum will swing as indicated. Likewise when suspended over a female hand it will rotate. In both cases, however, this is only for as long as the description of the movements programmes the expectation of the mind of the person holding the instrument. Suggest to another individual that when held over a man's hand the pendulum will rotate and that when held over a girl's hand it will swing in a straight line, and you will find that it will do so, acting in apparent contradiction to the earlier specifications. Just as, therefore, the successful water-diviner must know, albeit subconsciously, where his water is before the ideomotor effect can be seen to work, so one must also know the sex of the unhatched bird before one can guarantee success. The subliminal clues which the trained mind can pick up from a landscape, however, far outweigh those to be gleaned from the bare, standardised appearance of an egg without recourse to sophisticated scientific equipment.

Support for such reasoning was provided by the experiments of the French chemist Michel Eugène Chevreul in the latter part of the last century. Chevreul had read to his surprise that an iron ring suspended as described would swing over a bowl of mercury, in spite of the non-magnetic nature of the latter. When, however, a sheet of glass was inserted between the mercury and the pendulum the ring would become still and stay that way until the glass was removed. The tests were repeated several times with the same results, until Chevreul was blindfolded and told his assistant to cover and uncover the mercury with the glass at random while he held the pendulum above. Now the glass had no effect. Only when he knew the glass was there did it stop the apparent pull of the mercury on the iron ring. This proved that the motivating force was in his mind, an ideomotor response.

Tie a small weight – it does not have to be a ring – to the end of a length of thread or string and hold its free end between the thumb and forefinger of either hand. Don't try to make the pendulum swing. Keep your arm still, holding it steady by resting the elbow on the table, if you wish. Merely concentrate on the direction in which you would want it to swing if it were going to. You have a wide choice. To achieve the greatest variety of effect, draw a circle about six inches in diameter on a sheet of paper. Through the centre of the circle, at right angles to each other, draw two diameters A–B and C–D. If you hold the pendulum above the circle and let your eyes follow the line A–B up and down

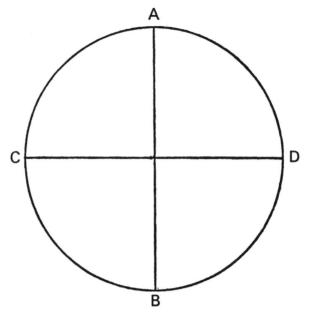

several times, gradually the pendulum will swing in that direction. Then transfer your gaze to the other diameter C–D and it will begin to swing from left to right. Shift your attention to the circumference and it will gyrate in either a clockwise or counter-clockwise direction. Which, depends on your mind. The more diameters you add to the circle, of course, the more intriguing the effect becomes. In addition, you can also will the device to swing in the path of an ellipse or to stop completely. Concentrate on the instruction and your mind will send the appropriate command through the nervous system to the muscles. Without any conscious volition on your part, they cause the pendulum to move accordingly.

The same principle makes possible an engaging experiment for which you require a drinking glass in addition to your standard pendulum. With your elbow resting on the table, let the pendulum hang motionless in the centre of the glass without touching the base or the sides. It is essential that the hand and arm be kept steady. If you now concentrate on a number or an hour, not only will the pendulum gradually commence to swing until it strikes against the side of the glass, but it will continue to strike the glass the appropriate number of times, no more, no less, and then gradually come to a standstill.

Many people place faith in the ability of the pendulum to raise to consciousness level their subconscious or intuitive feelings about an issue, confident that its swing can provide the answer to a vital personal question otherwise elusive in the course of everyday life. Maybe it could work this way for you. Whatever question you wish to have answered must first be broken down in such a way that it can be answered either by a single "yes" or "no" indication or by a series of

them. You must also decide which direction of swing is to indicate positive (say, up and down), and which negative (say, side to side). This is the technique often resorted to by private readers or fortune-tellers. Unable to answer a certain personal question safely — one pertaining, say, to health or finance — they resort to a form of "feedback", whereby the sitter finds himself, they claim, answering his own question, drawing upon knowledge already lodged in his subconscious. Maybe!

Body Trick 67

As long as the initial physical contact is maintained by the person from whose mind the ideomotor response emanates, it is possible for the impulse to be transmitted through not one, but several objects before it manifests itself. In the heyday of shady spiritualism in the nineteenth century, this little-known fact was put to staunch use by fraudulent mediums in a compelling demonstration of supposed telekinesis or "mind over matter".

To emulate their morally dubious, but biologically sound activities, you will need several transparent glass bottles, all of a different size, corks to fit them, and a selection of four heavy but small weights, such as nuts, screws or keys, which can pass through the necks of the bottles. Each weight is tied to a piece of thread which must measure a different length in each case. The longer the thread, the heavier the weight should be. The other end of the thread is then anchored between the bottle neck and the cork, causing the weight to be suspended within the bottle in such a way that it is clear of both the bottom and the sides. You also require a lightweight table — a card table is ideal — and four people to sit around it, one at each side. The four bottles, each with its own pendulum dangling inside, should be evenly spaced in a row diagonally across the table.

Wait for the pendulums to hang as still as they possibly can, remembering that the very rotation of the earth will impart an infinitesimal swing to them. Only then instruct the four participants to place their fingertips lightly but firmly upon the table top with their palms downwards. Somebody is now asked to nominate one bottle. Whichever is called, everybody must then concentrate in an effort to make the pendulum contained within that bottle swing. They must look at and concentrate only on the chosen container. Tell them even to imagine they are pushing the weight inside. Although the weights would appear to be isolated from all human activity, the concerted ideomotor effort, combined with the fact that each weight has a different rate of swing because each string is a different length, eventually causes the chosen pendulum to swing, while the other three remain still.

You then ask somebody to call out another bottle, whereupon they must all concentrate on that one. Very gradually the swing of the original pendulum will lose momentum while the new one will begin to pick up speed on its own account. The difference in length between threads means that the impulses that move one pendulum will cancel out the vibrations of another. Only one pendulum will properly swing at a time because the others are automatically out of step with the rhythm set off by the specific subconscious pulsations within the hands of those involved.

Body Trick 68

It is only a short step from being able to will the pendulum to swing within the chosen bottle to making the table itself respond to the power of concentration, the phenomenon known in mediumistic circles as table-tilting or rapping. It is important that the table used should be solidly built. If it has only three legs, tripod fashion, better still. The floor beneath should be hard. As many people as can be comfortably accommodated, sit around the table with their hands lightly, but firmly pressing down against the surface. In the last century much play was made of the necessity for one's little fingers to be in contact with those of one's neighbours, the hands thus forming a continuous ring. When the working of the table-tilting itself is understood, however, this would appear to be of minimal importance. If the participants, while making sure that they do nothing consciously to move the table, merely concentrate on the idea of it taking on a life of its own by tilting beneath their fingers, and if their imagination is sufficiently vivid and sincere, in time – after anything from five to thirty minutes – the table will begin to tilt backwards or forwards on two of its legs. When it straightens itself back in its earlier position, it inevitably produces a hard rap against the floor.

In spiritualistic circles these raps were interpreted as messages by those anxious to believe in communication from the other side. One knock would signify "yes", two knocks "no". When asked the time, the table would rap out the correct hour. In a similar fashion it would account for dates, ages, simple mathematical solutions, even whole messages. For the latter the alphabet would be spelled out aloud to coincide with a series of raps, until the latter stopped and the correct letter was reached. The participants would then proceed to the next letter of the word or phrase involved.

The table behaves in such an extraordinary manner because all those with their hands upon it are pushing it, albeit subconsciously. As long as they keep the idea of its movement paramount in their minds, their expectation once again produces the involuntary muscular movements

and pressures of ideomotor action, which in their turn are transmitted to the furniture. When an answer is sought to a question, the anticipated reply, which is always in the enquirer's mind, is subconsciously induced through the ideomotor mechanism. The staunch belief in some supernatural agency as the cause of the table's performance only serves to indicate how unaware the participants themselves are that they are doing anything to contribute to it.

It is worth adding as a postscript the interesting observation made by Bruce Elliott, the editor of *The Phoenix*, a magazine published exclusively for magicians in the Forties. It would appear to be mentioned nowhere else in the literature on the subject. He puts forward the unique suggestion that better results will be achieved if all those taking part in the experiment breathe in unison. Elliott claims that in an extensive series of tests over the course of a year not once did the table, whether a bridge table or one of the heavy dining-room kind, fail to respond in some manner for him and his associates once this guideline was observed.

Body Trick 69

A less time-consuming method of using the ideomotor principle to spell out information people want to hear is that of the ouija board, a term derived from the French *"oui"* and the German *"ja"*, both meaning "yes". It consists of a small wooden platform around which are printed the ten numerals, the letters of the alphabet and the words "yes" and "no". More simply you can arrange the letters from a Scrabble set around the edge of a smooth, highly-polished table-top. At opposite ends of the table place additional tiles to spell "yes" and "no". Whichever version is used, an inverted lightweight drinking-glass is then set in the centre of the letters. Everybody present now places a finger on the upturned base of the glass. When a question is asked by one of the participants, the glass will after a short while begin to slide over the platform in the direction of those letters, figures or words that indicate the answer corresponding to that participant's innermost thoughts or wishful thinking. It may appear to spell out words letter by letter of its own volition, but, in fact, is entirely motivated by the subconscious muscular reactions of those involved. Once again, however, positive results can be expected only if the concentration and desire for the phenomenon to manifest itself are as strong in those involved as their power to resist any conscious movements on their own part that would assist the effect.

There is a very simple way of proving that the physiological system of the participants and not some supernatural intelligence is responsible for success in this area. Simply scramble the order of the letters and

either cover them or lay them out face down accordingly. Under these conditions, the possibility of the glass spelling out a coherent message dissolves into thin air. Even the most devoted believer in communication with the spirit world will receive nothing but a meaningless jabberwocky of letters in reply to his questions.

Body Trick 70

Magicians have long used the theme of this section to stimulate the effect of impossible magnetism. A volunteer is required to hold in front of him against his waist a mirror or tray, ideally about two feet by three. Throughout the test he must keep this absolutely steady and horizontal between both hands. You then place a large glass marble in its centre. If the spectator is holding the tray correctly, it should not roll. Tell him to concentrate all his attention on the marble which, you say, will always follow the movement of your pointing finger. Insist that he must not tilt the tray in any way.

Holding your pointed digit over the marble you count to ten and then slowly move it away. To people's astonishment, glass is attracted by flesh. As soon as you tell the volunteer what is likely to happen, his expectation is keyed. He is not aware of tilting the tray in any way, but the subconscious muscular movement prompted by your powers of suggestion does it for you. The movement is so infinitesimal, though, that no one ever suspects any assistance from the tray. Alternatively, you can suggest that your finger possesses the power to repel the marble when brought into close proximity with it. You will find that the new idea, once implanted in the mind of the person holding the tray, manifests itself just as effectively.

Body Trick 71

Before you can put this particular item into operation, you will need to construct a small pivot board or platform. This should be a piece of strong wood about twelve inches square, through the exact centre of which you hammer a nail so that its pointed end projects one and a half inches from the other side. In addition, you will need two identical walking sticks, umbrellas, or bamboo canes.

The board is placed on the floor, pointed side down. Now stand on the platform, using the two sticks to maintain balance, in such a way that only the point of the nail is in contact with the floor. You must keep absolutely still and maintain equal pressure on both canes. In spite of this, if you concentrate intently on either right or left, you will find that the board will slowly turn in that direction.

Here the ideomotor response triggered by your concentration subconsciously produces a greater pressure on the appropriate cane, which in turn makes the board revolve. The important thing to remember is not to resist the platform when it starts to turn but to yield to its movement without consciously contributing to it.

Body Trick 72

In his researches into fortune-telling Dr. Stanley Jaks, the eminent German magician and mind-reader who flourished in America in the early Fifties, discovered an interesting method by which a fortune-teller would obtain contact with his client. Taking down a large locked edition of the Bible, he would extract the key, an appropriate symbol for the unknown, and balance it across the tip of the person's third finger at right angles to it. The client now had to direct all his concentration towards making that key turn over, without consciously moving any part of his outstretched hand in any way. If he succeeded in willing it to revolve, he got his fortune told. Needless to say, he always did.

It is important that the key is a heavy one with a round shank. Hold your hand upwards in front of you with the middle finger extended,

the others bent inwards. Make sure, when balancing the key, that it rests on the fleshy pad of the fingertip and does not touch the nail and also that the wards or notches of the key start out by pointing towards the wrist. All you do now is stare at the key and, keeping your hand perfectly still, literally will it to turn over. Slowly, spookily, it will rotate through 180 degrees, as if being turned by a ghost hand in an invisible lock. Only then will it roll right off the fingertip.

It will be obvious to the reader that the same forces that cause the pendulum to swing account for the key's movement. Most people, however, will have to experiment to find the exact position in which the hand should be held. Depending on the actual weight and size of the key itself, the exact spot where the imperceptible movements of the hand cause it to rotate will vary. With practice you will also be able to will the key to rotate in either one direction or the other.

Body Trick 73

In even earlier times a similar experiment with a key served the fortune-teller, ouija and pendulum-fashion, as a means of supposedly seeing into the future. A book of average size was opened in the middle and the key—again a heavy one, ideally with a round ring handle—was placed against the page so that the handle overlapped the top of the page. The book was then closed and bound tightly with string. The handle of the key was then balanced on two persons' extended forefingers, one on each side, the book suspended between them.

Subconscious muscular and nervous reaction on the part of the holders now caused the key to swivel round through ninety degrees. Guided by the spiel of the fortune-teller, the participants unwittingly caused the key to turn at those now-familiar moments like the count of a

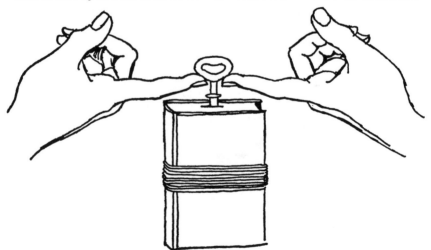

specific number or the spelling of a letter in a name. More exciting was its supposed power in olden times to reveal the name of a thief or other guilty party by twisting and turning when he was mentioned. Apparently, however, this would only work under certain conditions. The book had to be a Bible, the key had to be placed in contact with the Fiftieth Psalm, and both had to be bound together with a virgin's garter.

Body Trick 74

More down to earth, although seemingly quite as irrational, is the scope provided by the ideomotor principle for taking two matches for a walk, along the blade of a knife!

Get together a box of matches, an ordinary straight-edged table-knife and a sharp pen-knife. With the latter sharpen the non-striking end of one match and make a small slit in the same end of the other. Fit both matches together so that they form a V. You must now hold the table-knife so that its blade is parallel to and just slightly above the table-top. Invert the V and place the matches in this position astride the blade at the handle end, the striking heads lightly touching the surface of the table and the top of the V pointing ever so slightly away from you. If you now keep your hand absolutely still, you will be able to observe the matches themselves crawl from one end of the blade to the other.

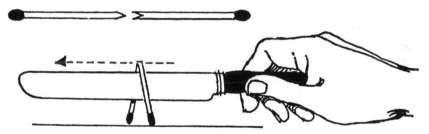

The movement is caused solely by the imperceptible movements of the hand and arm transmitted to the knife. Try as you might to stop the movement, the matches will keep on walking. As in all the tests in this section, the "law of reversed effort" comes into play. The more effort people put into keeping their hands still, the greater the unconscious movement that is externalised by means of the matches. As our muscles get tired, so muscle tension and movement increase. Therefore, the tighter we hold our hand and arm to stop the matches from travelling, the faster they walk. Or the pendulum swings. Or the table tilts. Provided always, that is, that the possibility that they just might do such things, in spite of our own conscious physical effort to restrain them, holds the centre stage of the mind from the beginning.

10 The Psychic Connection

It is reasonable to suppose that if a person's innermost thoughts can be made manifest through the medium of an inanimate object, such as a divining rod or a pendulum, then the slight ideomotor impulses subconsciously motivating those objects can be transmitted instead direct to the consciousness of a second party. That such a process is possible has for many years been a closely-guarded secret amongst exponents of stage telepathy. Those specialising in this technique have long been suspected by sceptics of using the more brazen means of charlatanism which one would associate with the stage magician. There would appear to be no other way, short of admitting the impossible. It is a delicious irony, therefore, to discover that they were in reality practising a discipline which, as we shall see later, comes as close to genuine thought-reading as one's wildest fantasy could imagine; almost frighteningly so.

Not surprisingly the most cooperative subject upon whom to work the technique that follows is the one prepared to admit to a belief in the real thing. If he or she concentrates intently on a single thought which involves location or movement, that thought will be translated subconsciously and invisibly by the nervous system into muscular activity with which, in one of several ways to be outlined, the performer has established contact. Even less surprisingly, therefore, the names most often used to refer to the phenomenon are contact mind-reading and muscle-reading although, in the case of the latter, nerve-reading would be equally apt.

The guideline for success in this area of mental exploration is always the fine distinction between the lines of least and of greatest resistance. Before we examine some of the more sensational challenges that can be met by heeding this discipline, here are three elementary tests which illustrate the basic principle at work in its simplest guise.

Body Trick 75

The initial test involves no personal contact of any kind. Few things, however, demonstrate more clearly the tendency of thought to manifest itself physically, unbeknown to the person initiating that thought. The individual undergoing fear, anger or sorrow is not specifically conscious at the time of the gestures which accompany his emotions. They happen automatically. Likewise the clue that allows the performer apparently to read minds in what follows.

Give a coin or some other small object to a friend. He is to hold it in his hands in front of his body, making sure it cannot be seen. Then, when you give the word, he is to spread his closed fists apart at arms' length and concentrate intently on the hand which contains the object. You tell him what is in his mind.

The secret is to watch not his hands but the very tip of his nose. If he thinks hard of the correct hand, his head will waver slightly in its direction at the moment he moves his hands apart. The tip of the nose is the key point to watch. Try not to be too logical about it. There is nothing to figure out. Look, be guided by what your eyes tell you, and call out the hand that suggests itself instantly. It is as simple as that. What follows is less so.

Body Trick 76

As with all the tests in this section, some will be able to do what follows as soon as they have read about it, others will require much practice. Most people realise they possess the knack suddenly when least expecting it.

Ask a friend to hold his right hand extended in front of him, his fingers and thumb spread apart star-fish fashion. You then tell him to concentrate intently on one of his five fingers. He must not say a word. He must not give himself away by his eyes. He must simply make the chosen digit the sole preoccupation of his thinking process to the exclusion of all else for the duration of the experiment. This is important.

You now apply your own right forefinger to each of his extended fingertips in turn, pressing down lightly but firmly. If he is following your instructions to the letter, you should be able to identify the chosen finger, since it is the one which should offer greatest resistance. The other four feel relatively limp by comparison to the digit towards which all his thoughts are directed.

Body Trick 77

Arrange six to a dozen playing cards or any other small objects in a circle or square upon a table. There should be at least four inches between adjacent cards. Make sure that the person whose thoughts you are going to tap is on your right-hand side. When he has secretly thought of one of the cards, you take hold of his left wrist with your own right hand, fingers on one side and thumb on the other, from above as if you were going to take his pulse. Your left hand takes a light hold of the fingertips of his same hand.

You must now impress upon him the need to relax and to concentrate solely on the direction in which you must move his wrist to locate his card. When you hold his hand over a wrong card, he must think either "go on" or "go back" accordingly; when you hold it over the correct card he must simply think "stop". In no way must he instigate or halt any movement on his own account. In no way, you further emphasise, must he consciously lead you to the card. Without realising it, however, this is exactly what he does. If he conscientiously follows the instructions above, he will, by means of the ideomotor principle, subconsciously provide the physical cues necessary for you to locate his card, in effect willing the actions essential on your part.

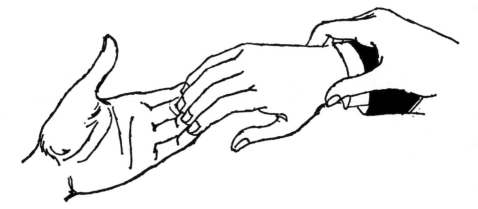

Slowly move his hand over and around the layout of cards on the table-top. You will discover that when you are guiding it in the general direction of your target, you will meet with less obstruction from his arm than when you are moving away from it. When you do arrive above the chosen card, you will detect an unmistakable halting impulse telling you that the spectator is reluctant for you to move his hand any further. Showmanship dictates, however, that you do not stop the first time. To be doubly sure repeat the circuit in the opposite direction, this time stopping as dramatically as you can over the target card. No one will be more impressed than the spectator who, without realising it, has irresistibly drawn you there himself.

Body Trick 78

The crux of the successful presentation, not only of the last test but also of the more spectacular variations that follow, is that while you create the strong impression that you are leading the subject, the reverse is happening. By keeping your own mind both as passive and as alert as possible, you will become even more sensitive to the in-

voluntary movements of his hand which provide you with the directions you need. In the classic vaudeville test of finding a small object hidden in a theatre during your absence, it is even more important that the illusion is maintained because of the amount of actual walking both performer and subject have to undergo while in contact with each other. Here it would be easy for the former to end up physically dragging his heels behind the latter as he headed for the hidden object; but that, of course, would make nonsense of the whole experiment. It is important, therefore, before we investigate the ramifications of the hidden object test, to establish the correct way of maintaining contact with the subject as you supposedly guide him on your psychic walkabout.

There are two factors to consider, namely the point of contact between performer and subject and their relative standing/walking positions. A great deal will depend upon experimentation as well as upon the right- or left-handedness of the performer. The right-handed person will almost certainly proceed better if his contact stands on his right side about one pace behind him. If the subject now extends his left arm, the performer can easily assume the method of contact detailed in the previous test and be free to walk about at the same time. The subject's arm should be relaxed and bent at the elbow so that you can carry its weight yourself. It is essential, too, that you keep the subject close to your side at all times. There will be occasions when you will need a free hand to move or locate an object or person and have therefore to release the hold on his fingertips by your left hand. As long as contact is maintained by your right hand, however, you will lose virtually no impulses at these moments. In appearing to steady the spectator's hand, the left hand is merely providing back-up for the right. It is important to remember to hold the subject's wrist steadily, but not tightly. Too tight a grip will restrict the free flow of ideomotor impulses from coming through to you.

The particular presentation of these principles which established the reputations of both Stuart C. Cumberland and Washington Irving Bishop, respectively the leading British and American exponents of contact mind-reading in the latter half of the last century, was the pin test. Having selected the subject whose mind he was going to read, the performer was led out of the room. In his absence, the subject would conceal the pin anywhere he desired. In theory there was no limit to the ingenuity of the hiding place. It could be between the pages of a book, behind a picture on the wall, in the stem of a plant. The deed done, the mind-reader was called back and, without asking any questions, would lead the subject to the exact spot where the object was hidden. That is the effect which those present carried away in their minds. To achieve it, as anyone can, it is necessary to take note of several points in addition to the details of the contact hold.

It should be stressed before you leave the room that the person must

not hide the pin on himself. Should he do so, it would become next to impossible for you to find it, flooded as you would be by positive impulses from which you would be unable to make the distinction upon which success depends. Secondly, it is advisable to suggest that the pin is not placed above the heads of people in the room or too near ground level. It could still be found, of course, by the same methods, but the whole operation would become considerably more cumbersome. Thirdly, when you have returned and taken hold of the subject's wrist as described, you must explain that he is not merely to concentrate intently on the position of the pin, but also step-by-step on the direction in which you must proceed in order to discover it. If he wishes you to go forward, his mind must say so. If he wants you to go right or left, this way or that way, he must concentrate accordingly. Whenever you make a wrong movement, he must think, "stop". Make it clear, though, that in no way must he lead you, secretly confident as you are that as long as he is thinking hard of the direction you must take, he is leading you regardless.

Commence by standing in the centre of the room and taking hold of the subject's wrist as described. If you do not immediately receive a clue by way of a distinct movement in the required direction from the wrist, make one swift step forward. This will result in either a positive or negative reaction subconsciously on the part of the subject. If you have taken the wrong direction, you will be aware of a slight checking impulse, a restraining pressure from his hand. If you are on the correct trail, you will feel either no pressure at all or a confirmatory impulse from his wrist in the right direction. The golden rule is always, where possible, to follow the line of least resistance, until you come up against a barrier. When you do, pause and/or step in a new direction in order to receive the new impulses that will put you back again upon the proper path. Success depends totally upon your instinct for telling when the subject is stopping you or letting you proceed.

You will know when you are in the close vicinity of the pin because the spectator's impulses will seem to be saying "stop" in every direction. At this point stop walking. Suggest that he imagines an invisible line from his hand to the exact hiding place and that he wills you to move along that line. Almost at once you will feel his hand move ever so slightly in that direction. If several possible hiding places still suggest themselves, instruct the subject to concentrate on the exact object which conceals the pin. Release your left hand from his and move it in turn over and around the various options. Tell him that when you come closest to your target, he must mentally picture your hand closing around the object. When this happens you will feel a distinct tug from his hand. Only then do you actually lift the object, pull back the curtain, or whatever is required, and stand back – pin held high – to take your applause. If at any time during the whole procedure, you are

in doubt regarding the direction you should take, simply ask the subject to concentrate harder on which way you are to move.

By following this advice there should in theory be no limit to the area over which the hidden object can be hidden, provided that the person with whom you hold contact knows the exact place it occupies in the area. In December 1950, as part of a feature for *Look* Magazine, the Hungarian-born Franz J. Polgar, one of America's leading stage telepathists of the middle part of this century, successfully located a small silver banknote clip which had been secreted somewhere in the 102 storeys of the Empire State Building. A further measure of his skill and sensitivity can be gained from a description of the stunt with which he climaxed his stage show, in spite of the misgivings of his agent, apprehensive that he had said goodbye to his commission. The object Polgar entrusted to his subject for hiding was no less than his cheque for that appearance. If he failed to find it, he would forgo his fee. Like Kreskin, the genial psychic who successfully duplicates the routine today, he always left the theatre more affluent than when he went in. On one occasion, so the story goes, after acknowledging the applause due to him for discovering his cheque, which had been concealed in the heel of a young lady's shoe, Polgar asked the organiser of the function if she had read the small print of his contract. She admitted that she had not whereupon, tongue-in-cheek, he called her attention to the clause which stipulated that should he find the cheque he was to be paid double!

Body Trick 79

It seems worth a separate section to underline the fact that there is no thought, however complex, that cannot be communicated by contact mind-reading, provided that it involves positive action of some kind. The only stipulation to make is that the action or command decided upon must have nothing to do with any object physically on the person of the performer or his subject. It is essential, however, that whoever acts as thought-transmitter concentrates on each step of the total sequence in turn, if you are to carry out the mental command to its conclusion.

Let us assume that in your absence the audience has decided that you are to take the handkerchief from the breast pocket of a gentleman seated at the end of the third row and to tie it around the wrist of the lady at the opposite end of the same row. Here it would be necessary for the subject first to will or direct you mentally to the correct gentleman, then to his handkerchief, then to the lady, then to her wrist. Should the gentleman be wearing an overcoat over the handkerchief, the subject must concentrate on the action of unbuttoning the coat first.

Moreover, you emphasise that with each step of the action, the more the subject actually imagines himself doing the appropriate task, the more successfully you will respond to his thoughts. So he must actually feel himself undoing the coat or tying the handkerchief in a knot. And, of course, whenever you do the wrong thing, he must think "stop".

For those sceptical of their ability either to find the pin or to decipher a more complex action, there is an easy compromise, namely the simple location of a human being. Showmanship demands, however, that this be built into something seemingly a little less mundane. Two tried and tested ideas are the letter delivery and the murder game tests. In the former the subject writes the name of another party on a sheet of paper, seals it in an envelope, and then recalls the performer. The latter now becomes the postman whose successful delivery of the "letter" held in one hand depends upon his interpretation of the sub-conscious cues received from the subject by the other. To enhance the effect, the envelope can be sealed between boards or locked in an elaborate container; anything that will thoroughly convince the audience that the name cannot be read by cheap trickery. In the murder hunt the audience decides who shall play the part of both the assassin and the victim. Subsequently, the subject unwittingly "leads" the performer to the corpse, who in his turn can "guide" him to the murderer.

In an article entitled "The Physiology of Mind-Reading", published in *The Popular Science Monthly*, February 1877, Dr. George M. Beard concludes that intuitive reasoning from ideomotor impulses is not only possible, but inevitable. Everyone has the potential for so-called muscle-reading, although not everyone is capable of maintaining the highest degree of proficiency in the art. Then he draws a fascinating analogy: "Every horse that is good for anything is a muscle-reader; he reads the mind of his driver through the pressure on the bit, and by detecting tension and relaxation knows when to go ahead, when to stop, and when and which way to turn, though not a word of command is uttered." You could call it "horse sense".

11 A Suggestion Of Hypnosis

Since the great days of Ancient Egypt, when priests as credulous and superstitious as the members of their laity leant upon its effects in the promulgation of magic as a fundamental reality, hypnosis has been accepted as a force not to be tampered with lightly. Since then it has remained shrouded in a mist of false statement, uncertainty and debate. Even in our scientifically enlightened age the hypnotic state still resists precise definition.

It is easier to be categorical about what it is not. Although its name is derived from the Ancient Greek word for "sleep", it is not a form of sleep as such. While it may be produced by the suggestion of sleep, the subject does in fact maintain a relaxed, conscious state, aware of what is happening around him. Moreover, the brain wave readings of hypnotised persons provided by electroencephalographs or E.E.C. machines show a waking, as distinct from sleeping or dreaming state. Nor does it provide a passport to complete control over the subject, who is still capable of exercising free will should he find the hypnotist's command disturbing or offensive. It is certainly not a God-sent gift for healing, although, apart from any fringe placebo benefits accorded those who think otherwise, it can deaden as distinct from eradicate the cause of pain. And yet neither is it an anaesthetic. The standard chemical anaesthetic works by acting as a barrier to painful nerve impulses on their way to the brain. Under hypnosis, however, the brain somehow "cuts out" and mysteriously ignores those same impulses, while the blood pressure and pulse rate react as if they *were* connecting and pain was being felt.

The one positive statement that one can make is that not everyone can be hypnotised. To begin with, the subject must believe in the hypnotist's ability. Further, he must have no qualms about revealing secrets, appearing foolish, or committing indiscretions in the hypnotised state. There are in fact only two ways in which the stage hypnotist, the practitioner most anxious to avoid failure, can guarantee certain results, either by coercion or by temporarily cutting off the supply of oxygen to the brain. Both ways are spurious. The former involves a secret kick in the shins or punch in the ribs, should the "subject" fail to respond to the on-stage instruction whispered out of microphone range; the latter — resorted to when even that fails to produce cooperation — involves exerting pressure upon the subject's carotid artery under the pretence of pushing back his neck, a tactic borrowed from judo, which produces unconsciousness through saturating the brain with carbon dioxide as a result of cutting the blood flow. Press too hard or too long and the

process can be fatal. The ethics of any performer who attempts it on a stage are themselves questionable.

As explained in its opening pages, this book is an exploration of positive body functions. Given the uncertainty and indefinability of the entire hypnotic process, it might seem surprising to some readers to find the subject being paid even glancing attention here. While this is not the place, however, to catalogue the various induction techniques used by genuine practitioners to produce hypnosis in the five per cent of the human population who, according to statistics, are susceptible to its deepest form, there are few people who are not susceptible to the basic principles of suggestion, the *sine qua non* on which all hypnosis depends. If hypnosis is anything at all it is a state whereby the conscious mind is inhibited, usually by the repetition of various stimuli, to the point where it can entertain only one suggestion to the exclusion of all others. At the quasi-anaesthetic level, for instance, it is presumably through the influence of suggestion that the mind is able to transcend its normal capacity in the extraordinary control it exerts over the body.

While suggestion is the basis of all hypnosis, it is capable, as many stage "hypnotists" have discovered, of producing seemingly genuine hypnotic phenomena without the need to induce the authentic condition. Indeed that rarity, the authentic stage practitioner, will often use them as a preliminary to and means of achieving the latter, each item gaining extra force as a result of the inevitable contagion of ideas and emotions to which we are all subject. Because it is within the reach of everybody to induce these effects in others, they form the basis of this section. Sometimes little-known biological knowledge is called into play to strengthen the suggestions made, but all rely to some degree on the principle that when an idea is registered sufficiently strongly in the mind it will, as we saw in a not entirely unrelated way in the last two sections, manifest itself subconsciously or automatically in action or belief. Let us now put this into practice for ourselves.

Body Trick 80

What follows is a perfect example of the human capacity for accepting an idea and responding to it almost automatically. You announce to the surprise of a friend that you see he has a scratch on his arm. In fact no such blemish exists, but you continue, "Does it itch?" He'll dismiss both your observation and your query, but you persist, looking all the more intently at his arm. You don't give in. You are sure you see that scratch on his skin. In time, whether or not he begins to doubt his own eyes, he will almost certainly feel the need to scratch the invisible mark, at first only furtively, but as the itch becomes more intense, openly, out of a craving for sheer relief.

Similarly, stage hypnotists have been known to confront their audiences with a spiel to the affect that in a short time they will begin to experience itching sensations on various parts of the body, sensations so strong that they won't be able to restrain from scratching them. As the patter continues, so specific parts of the body are mentioned. To underline the suggestion the performer may casually—but not obtrusively—scratch himself. Before long most people in the audience will be scratching itches on, say, their heads, shoulders and arms that exist only in their minds. Proof that this works? How many times did you scratch yourself while reading these words?

A variation of the above, equally effective on either an individual or a group, is to suggest that the audience will feel a tickling situation in the throat, coupled with a violent urge to swallow, an urge which it must not resist. It is more important that it enjoys the relief which swallowing provides. As he talks, the performer himself swallows. Within seconds everybody will be soothing their imaginary tickles by doing the same.

Pause to think and you will realise that there are many analogous situations. When one person in a crowd coughs and other people follow suit, when you get the urge to yawn upon seeing someone else yawn, or when your eyes start to water upon spotting another person who is misty-eyed, then the same aspect of suggestion is being called into play.

Body Trick 81

You may not believe this until you try it for yourself. You require the assistance of a small group of people and a small glass jar with a cork or screw-top lid. The jar should contain pure water and nothing else.

You show it to the spectators, explaining that it contains a very exclusive perfume from foreign parts. The more exotic your description, the more successful you will find the results of the test. You tell them that you are going to uncork the jar to enable the scent to waft around the room. As soon as they can smell it they are to raise their hands. Amazingly, seventy-five per cent on average do put up their hands. Ironically, of course, the laws of suggestion are such that if the performer prefaced the experiment by describing the liquid within the jar as especially obnoxious, the very same hands would again go up in the air.

Body Trick 82

Close your eyes and imagine that you are cutting a large, sour, bitter lemon, a lemon so full of juice that it is dripping to the floor. Imagine

you are sucking that very juice from the same fruit. It would be surprising if your mouth is not already awash with saliva. Once the lemon itself has provided you with the idea of sourness, nothing can prevent that idea from being realised in the mind and triggering the salivary glands to secrete in the process.

An amusing variation of the above is to ask a friend to start whistling a tune. You then proceed to implant the suggestions of the above paragraph in his mind, either by describing an imaginary lemon or, preferably, by producing a real one and actually sucking it on the spot. In the latter case, you should still break off your "refreshment" to emphasise from time to time how bitter and sour its juice is. You should even take your handkerchief from your pocket to wipe the saliva from your lips. In a short while the subject will stop whistling, the best he can do being to carry on blowing with no sound whatsoever, because of the saliva flooding his palate.

Body Trick 83

It is not always necessary for the suggestion to be made directly; often it is enough merely for the idea to be implied. For example, when you next catch a colleague absentmindedly whistling or humming at work, very casually, without attracting his attention in any way, begin to whistle another tune. You should start softly but gradually increase the volume. It is most likely that he will change his tune to yours without realising what has taken place. You will often find that when you tell him what has happened, he will insist that yours was the tune he was whistling all along.

Body Trick 84

The success of the following depends upon the combination of suggestion and the physical fact that the knuckles are larger than the bones of the fingers, so that when the fingers of one hand are interlocked with those of the other, unclasping becomes somewhat difficult in any situation. The test involves asking the members of the audience to interlock their fingers in this fashion and to hold their linked hands with their palms against the top of their heads. In this position they must pull downwards, still keeping their hands joined. A few seconds later, tell them to turn their hands over so that the knuckles are against the skull. They must still maintain the downward pressure. You now suggest in an authoritative voice that they will be unable to extricate their hands from this situation until you desire. Moreover, they must concentrate on the idea of being unable to unclasp them. Let them try.

You will find that the majority of people are unable to do so. Instruct them to stand and to reverse their hands again, bringing their knuckles upwards, and then suggest that now they will be able to extricate their hands from each other on the count of three. Of course, they do so quite easily.

An even more certain way of achieving the same effect is to ask the subjects to interlock their fingers with their hands extended at arms' length straight above the head. As before, start with their palms downwards, and tell them to turn them upwards. As long as they keep their hands held at this height and do not bend their arms, there is no physiological way possible in which the average person can disentangle his fingers in this position.

Body Trick 85

There is no reason why this test, like the preceding one, should not be worked on the entire audience at the same time. Tell everyone to hold their hands in fists in front of them about fifteen to eighteen inches apart, their index fingers pointing towards each other. Then suggest to them that their fingertips are becoming nervous in this position and consequently are not pointing together exactly. As a result, you continue, they will have difficulty in making the tips touch. At this point you invite them to bring their fingertips together instantly, with emphasis on the last word. The action must be swift and continuous, without any hesitation.

This sounds like the easiest task in the world, but the merest suggestion of doubt is enough to throw the average person off his guard. The slightest wavering or hesitation is all that is needed to score a miss. Some will succeed, of course, but most will fail. In the case of the latter, the harder they continue to try, the greater the distance by which the fingers miss the next time they pass each other.

Body Trick 86

Here is a way of ensuring that fingertips which missed each other last time around do end up touching. Ask somebody to clasp their fists together, but to keep their two forefingers extended with a gap of about an inch between them. You announce that you are going to attempt to bring those digits together without touching them. He must not consciously move them.

To do so, you simply mime a winding action with your own hands on each side of his. In time his extended forefingers will slowly move towards each other, a combination of both suggestion and fatigue. As

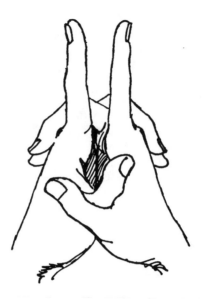

you will find, it is tiring to keep the forefingers apart in that position for any length of time.

Body Trick 87

In effect you successfully suggest to your subject that when he closes his eyes he will be unable to open them until you give him the appropriate word. In fact, if he keeps to the instructions with which you embellish the suggestion, it is physiologically impossible for him to open them anyway.

You can try it on yourself. First look straight in front of you and then roll your eyeballs upwards without raising your head. Keep your eyes in that position. Now close your eyelids, still keeping your eyeballs looking upwards towards the sky or ceiling. As long as the last two instructions are combined, you will be unable to open your eyes. If you can, you will be making medical history.

Body Trick 88

Ask somebody to hold one arm stretched out horizontally from the elbow, with the palm of the hand turned upwards. Suggest to the subject that you are going to exert a magnetic force upon the arm, whereby he will be made to raise it in spite of himself. Stroke his extended hand from the wrist to the tips of his fingers about five or six times in rapid succession, exerting a steady downward pressure as you

do so. You explain to the subject that he must try to keep his hands from being forced downwards while you stroke them.

The last time you go to stroke his hand, however, you do not touch it, but move your hand upward. As a result the subject involuntarily raises his own arm, basically a reflex action as a result of muscular tension coupled with the effect of suggestion. Having resisted your pressure on each preceding stroke, his arm is by now conditioned to press upwards and rises automatically, as if drawn mysteriously by your own. It is important that when you come to make the last "stroke" you act exactly as you did at each previous one, as though you are about to press down hard again, until the point where you suddenly lead the subject astray.

There does exist a related phenomenon which one can try out on oneself. Stand in a doorway and, with your arms extended at normal length, push the backs of your hands against the door-frame as hard as you can. Stay there for a minute or so, exerting a steady outward pressure all the time. When you think sufficient time has passed, relax, let your arms hang free, and walk away from the door. As you do so, both arms will rise from your sides like those of a puppet on a string.

Body Trick 89

Have a friend stand erect with his feet together, arms at his sides, and head tilted upwards slightly. His weight should rest on his heels. Tell him to close his eyes and to relax. Stand about two feet behind him with the tips of your fingers pressing gently against his shoulder blades. Then, in a quiet but assertive voice, say something like, "You are going to fall backwards . . . backwards . . . backwards. Don't resist. Do not be afraid. When I take my hands away, you will fall slowly backwards into my arms. I won't let you drop." You stress that he is not to try to fall deliberately, not to resist falling, merely to think of the idea of falling. As you keep talking along these lines, relax the pressure coming from your fingers and gradually move your hands away. After a few seconds you will find that he will sway towards you and fall back into your arms.

Alternatively, you can position yourself in front of the subject. Standing slightly to his side hold your palm flat against his forehead, having ensured that he has shifted his weight to his toes. Deliver a similar line in suggestion to the one mentioned above, only this time emphasising that he will feel an irresistible force pulling him forward. Slowly move your palm away from his forehead. In time he will sway forward. Once again make sure you catch him.

It is important in both tests that the subject does not fight the suggestions given. If he lives up to this expectation, the combination

of having his eyes closed and his head tilted causes him to lose just a slight degree of balance, which makes him all the more susceptible to your suggestions.

It is easy to prove to yourself that thought can affect the sense of balance directionally. Think intently of some object which you wish to reach on your right. Without consciously moving your body, you will find that it automatically inclines in the appropriate direction. Likewise, think of something on your left and your wish to touch it, and your body will sway to the left. As we saw in our study of ideomotor action, the thought combined with the "law of reversed effort" produces an involuntary as distinct from voluntary effect, rendering the actual fall or sway all the more eerie to the person experiencing it, who knows full well he is not falling on purpose.

Once you have scored success with the above, you can progress to a more advanced test in which the suggestion of swaying is not even made verbally to the person who is going to sway. You will need the cooperation of five people, one of whom is sent outside the room, while the others form an inward-looking circle. They secretly agree upon one of their number – henceforth the "target" person – and then call back the fifth party, who is stood in the centre of the ring with his eyes tightly closed and then turned around a few times. When he is still, those on the outside place their fingers gently against his chest, back and shoulders, without exerting pressure of any kind. They must now think intently of the target person in their midst and silently will the subject to sway in his or her direction. Within a short while the person in the centre, depending upon the level of his own suggestibility, will do just that, whether backwards, forwards, or sideways, into the arms of the chosen person. Reflect carefully and you will see that this amounts in effect to a curious inversion of the basic contact mind-reading situation discussed in the last section. The subject in the centre of the ring fulfils the performer's rôle in that he successfully locates the chosen party, while at the same time having no idea of exactly what is happening, let alone how.

Body Trick 90

The last experiment in this section is as much an illusion as a display of mock hypnosis, but it also demonstrates admirably how, as in genuine hypnosis, the successful subject of mere suggestion responds physiologically in exactly the same way as he would to the physical reality. For this very reason, you must make sure that the person you choose as that subject is robust, unshockable and not in possession of a weak heart.

You also require two accomplices who are taken into your confidence beforehand. They are positioned at opposite ends of a plank on

which the subject, who must be blindfolded, is to stand. You yourself stand directly in front of the subject and instruct him to place his hands on your head to steady himself as he is lifted into the air. Your two helpers are then told to lift the plank slowly towards the ceiling. That, at least, is what the subject hears you say and thinks they do. In fact, they lift the plank only a few inches off the ground, while you sink slowly to the floor by bending your knees into a crouching position. Your own movement gives the unsuspecting victim the impression that he is travelling upwards a distance of some four or five feet or more.

When you have sunk on to your heels and can go no lower, tell the victim to take his hands away and keep his balance while you duck out from beneath him. Then dare him to jump. Most people are far too frightened to do so. If he hasn't already toppled over in panic and discovered how close he was to terra firma, whip away the blindfold and show him. People really do think they have been lifted to great heights. Obviously for the experiment to be most effective it should be performed out of doors or in a high room so that the ceiling (or its apparent absence) does not give the game away to the subject.

12 Blood Sport

The life of everyone who reads this book depends upon a canal network measuring hardly less than 60,000 miles, a distance which must put most airlines to shame. This is the transport system of blood vessels, by means of which our blood distributes oxygen, water and food in the form of glucose, amino acids, fats and vitamins to every single one of the body's sixty billion cells and then ferries away their wastes. The bloodstream, however, cannot circulate on its own. To do so it relies predominantly upon the heart, an organ weighing twelve ounces that resembles a pear, is in actual fact a pump, and as far removed visually from the motif beloved of playing cards and St. Valentine as one could possibly imagine.

The heart comprises two muscular pumps. The pump on the right side expels blood into the lungs where it exchanges carbon dioxide (i.e. spent oxygen) and water for fresh supplies of oxygen, prior to returning to the left pump which despatches it to the arteries. Having delivered its supplies around the body, the blood then returns to the first pump through the veins. The capillaries, so thin that red blood cells can pass through only in single file, provide the U-turns connecting the two one-way streams, which the arteries and veins really are.

With the exception of a woman's uterus during childbirth, the heart is the hardest working muscle in the body. Some idea of its industry can be gained by cupping your hands in a bowl of water, squeezing the water out, and then relaxing to allow the water to enter the hands again. Keep this up for a while and your hands will soon become tired. Then try to reconcile the fatigue so gained with the effort required to pump on average the equivalent of 4,000 gallons of blood each day of the human life. Pumping as it does in surges, each one of which would just about fill half a teacup, the heart is complemented by the bigger arteries, which even out the irregular flow to enable the blood to arrive in the extremities at a steady stream.

Body Trick 91

When you become flushed with pleasure or exercise, it means that your capillaries are operating at full capacity, the skin's requirements for those essentials which only the bloodstream can provide having increased enormously. Conversely, when you go white with fear, it means that the blood has fled from the capillaries at skin level and is rushing through the muscles in anticipation of the physical ordeal you will

probably have to face. The latter condition, however, can be caused more simply by gravity, a fact which magicians have used to their advantage as the basis of an extempore mind-reading mystery almost since time began.

A spectator is given a silver and a copper coin with instructions to hold one in each hand with his hands on his knees. While the magician is out of the room, he must think of one of the coins and hold it in front of his eyes or against his forehead while counting to twenty or reciting an appropriate magic spell a specified number of times. He must then lower this hand and call back the magician who will instantly guess which holds the coin he concentrated upon.

All you have to do is detect which hand is a shade lighter than the other, or, in other words, the one whose blood vessels are less dilated. An appreciable amount of blood will have drained out of the hand held up in the air, at the same time as more will have rushed into the hand held throughout on the knee.

Body Trick 92

Whenever an artery is near the surface of the skin it is possible to detect by touch the rhythm of the heart contracting and relaxing in turn as it pumps blood around the body. This is what the medical profession refers to as the pulse. It is not caused by blood passing through the artery at about eighteen inches a second, but by a pressure wave

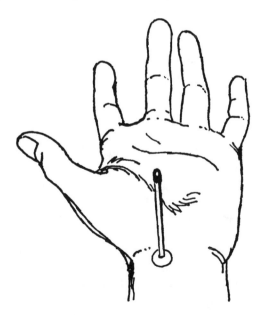

transmitted from the heart in response to the surge of its pumping action, which travels at the even more amazing speed of about twenty-one feet a second.

Everyone is familiar with the standard method of "taking the pulse", namely, holding the wrist in the appropriate spot with the second or third finger. The reason why the thumb becomes redundant in this capacity is that it has a pulse beat of its own, which will only interfere with the other. What many people do not know is that it is possible to see the pulse beat, as well as to feel it. Moreover, to do so you no more need the expensive electronic equipment of today than Sir John Floyer who in 1707 became the first physician to time the pulse rate as part of a routine medical examination.

Stick a drawing pin with a slightly round head into the non-striking end of a match and balance the combination, with the drawing pin for base, on your wrist at the spot where you feel the pulse strongest, just below the base of the thumb. You will then be able to see the match vibrate backwards and forwards with each heart beat like a miniature metronome. If you have difficulty balancing the device on your arm, you can make life considerably easier by resting your wrist comfortably upon a table.

Body Trick 93

The pressure wave transmitted from the heart to the arteries can be momentarily disturbed by the sudden inrush of unexpected blood. The mere act of thinking intently of a specific part of the body increases the flow of blood to that part, causing the pulse in the appropriate area to skip a beat. You can prove this for yourself.

Stand opposite a volunteer, your right hand holding his left wrist and your left hand his right, fingers naturally but not obviously in contact with his pulse spots. Once you have become attuned to his regular pulse beat, command him to think of one of his arms, the right or the left. As soon as he does so, you—to his amazement—lift that arm.

Whichever arm he thinks of, the pulse in that wrist will first slow down and then quicken, while its opposite number stays the same. Should you get a confused reaction from both pulses, as distinct from a clear-cut response from one, it means that the subject cannot make up his mind, something you tell him to his complete astonishment. You can repeat the experiment as many times as you wish, provided that on each occasion you tell him to clear his mind and make sure that he does not think of an arm until he is specifically told to do so. Obviously you have to wait for his pulses to resume their regular beat before you can go ahead a second time.

Body Trick 94

If you apply sufficient pressure to an artery, both the circulation and pulse beat will cease along it. Apply that same pressure secretly and you can bluff your way into membership of that exclusive coterie of fakirs, who claim to be able to exert supernatural mental control over the basically involuntary body functions. And yet, however genuine, albeit controversial, the powers of the more skilled fakirs, it is hard to imagine that on occasion even they do not resort to the white lie of trickery. If so, this is the method they would most likely use.

Conceal beneath one armpit a small, hard rubber ball—a golf ball is ideal—or a two-inch block of wood. In an emergency a handkerchief rolled into a tight wad and knotted upon itself several times will serve almost as well. If you now press that arm against your side, the pressure will gradually cut out the axillary artery which runs from the heart, underneath the armpit and down the entire length of the arm, carrying blood to the hand. The beat of the pulse will first slacken and then fade away altogether, to the scared amazement of the spectator you enlist as an independent witness to your uncanny powers. Release the pressure, however, and in seconds the pulse will be found to be beating at its normal rate again. A similar though less impressive effect can be obtained by hanging an arm over a chair-back and pressing down with your armpit accordingly. Whichever method you use, for safety's sake make sure that you maintain the cessation of the pulse only just long enough for the effect to be registered.

If you are content merely to achieve moderate acceleration or deceleration of the pulse, without actually bringing it to a standstill, you have only to adjust your breathing. A slow, deep breath held for as long as possible limits the supply of oxygen to the heart and consequently produces a slower pulse beat. Following this, exhale slowly and resume breathing normally and the pulse will begin to beat even faster than normal, due to the effort of the heart to adjust to the lack of oxygen. As a demonstration of superhuman powers, this requires a certain amount of practice in making sure that your audience is unaware of the variations in your breathing pattern. However, it does become easier if you incorporate it with ideomotor technique. In other words, when you wish the pulse to slow down you actually concentrate your whole mind on the idea of the heart pumping more slowly. Similarly, when you wish it to go faster, you imagine that it is racing ahead abnormally.

Body Trick 95

The information that follows will enable you to go one step further in emulating the miracles of the Indian fakirs by providing visible proof that you can control the flow of blood. To all appearances you take a sharp knife and inflict a deep cut on your thumb just below the nail. Blood oozes out on to hand, handkerchief and blade, but when you wipe it away the cut is seen to have healed instantly. There is not even a trace of the slightest scratch. As carnival showmen would insist, it even baffles the medical profession.

Not too long before you present the feat, you moisten your left thumb with saliva and secretly prick it with a needle about three or four times in a line parallel to and about a quarter of an inch beneath the base of the nail. Make sure that the needle is sharp and sterilised. As long as you keep the thumb straight and rigid at this stage there should be no bleeding. You first wind the end of your handkerchief tightly around the base of the thumb, holding it in place by closing the fist around it. Then take a pen knife or any blade of similar size which looks sharp but is in fact blunt and pretend gently to slice the back of your thumb in the appropriate place. Of course, you only mime the cutting process, but as you do so you bend the thumb inwards as tightly as possible. This coupled with the pressure from the handkerchief produces sufficient congestion in the end of the thumb to cause a fair quantity of blood to trickle out of the needle pricks. Drawing the blade across the thumb, as if you were making a cut, smears the blood across the skin and produces the illusion of a disastrously deep gash. To cause it to heal instantly without leaving the trace of a scar you have only to straighten the thumb again and wipe it clean with the handkerchief which should, of course, be white for effect.

Body Trick 96

Much controversy was caused in America shortly after the Civil War by a fake spirit medium called Charles Foster. Whereas other mediums were mysteriously causing messages which came supposedly from beyond the veil to appear on slates, he made them appear in bold crimson letters on his bare arm. The phenomenon became known as blood-writing.

The methods used by Foster to obtain from his followers the secret information that would subsequently be spelt out upon his flesh need not concern us here. Let us assume that somehow he had discovered, unbeknown to her, the name of a widow's deceased husband and that he was going to call upon the spirits to make this name appear as

described. Once Foster had excused himself from the séance room upon some pretext, he had only to trace the letters boldly on the skin of the lower side of his left forearm with his right thumbnail. You will have to experiment to find the exact pressure to be applied, because the sensitivity of skin differs from person to person. The initial tracing will produce white lines which soon disappear, leaving no trace of what you have done. Foster would then return and have people examine his arm. The skin would appear to be in normal condition. He would then stoop down and thrust his arm beneath the table. In this position he had only to rub the arm vigorously for a short while with his free hand to cause the writing to manifest itself. Once the mysterious message had been displayed it would then fade away of its own accord as eerily as it had appeared.

Rubbing the arm produces heat, as a result of which the blood vessels within the skin dilate, and the arm consequently appears flushed. This is because part of the skin's job is to radiate heat to the outside to get rid of it. In the cold, the reverse happens. The same vessels close, causing the blood to make a detour to the interior of the body. Consequently one looks pale by comparison. It is obvious, therefore, that in the former situation any area of skin that has lost an appreciable amount of the epidermis (the dead cells which make up the skin's top layer) will appear even more flushed because more transparent.

13 "May The Force Be With You"

It is a paradox that if you attempt to push down a door or a wall the part of the body upon which you most depend is not pushing but pulling. One's muscles can only work by pulling. That the pulling is eventually converted into pushing we owe to the body's subtle engineering system.

It is easy when embarking upon a biological study to overlook the partnership that exists between flesh, muscles and bones on the one hand and mechanical principles, more usually studied under the less anatomical guise of physics and mechanics, on the other. Throughout the years, however, a knowledge of mechanical principles as applied to the human body has been successfully employed by showmen in performing feats of apparently superhuman strength, to the awe-inspiring extent of seeming to endow them with the ability to nullify the force displayed by the strongest men in the world.

In the latter part of the last century no one was more successful in this regard than Lulu Hurst who, billed as "The Georgia Wonder", reaped publicity of Gelleresque proportions while still in her teens. She laid claim to an unknown force under the influence of which she could push the heaviest men around a stage in spite of their sturdy resistance and her own frail physique, withstand the efforts of those same men to lift her, as well as cause inanimate objects to obey her will without any apparent muscular action on her own part. No less eminent a man than Edison was of the opinion that this "force", when displayed by Annie Abbott, "The Little Georgia Magnet", a later rival of Hurst, was some kind of electricity incapable of scientific explanation. In fact neither colossal strength, magnetism nor electricity was involved. Both possessed a sound knowledge of unrecognised principles of leverage, inertia, and the deflection of forces. Many of the feats which they performed in addition to others featured by less controversial charlatans are outlined in the pages that follow. Anyone of average strength, who follows the instructions correctly, should be able to carry them through successfully.

Body Trick 97

The test about to be described has been presented both as a feat of apparent superhuman endurance and of mock hypnosis. In fact, it is not necessary for the person who is stretched out at full length to be

either hypnotised or to be in possession of Herculean powers. Some strength is required, but far less than one would imagine upon witnessing the demonstration.

You need three sturdy chairs of equal height and at least two people to assist you. Position two of the chairs facing inwards about eighteen inches less than your own height apart. You will need to experiment to find the exact distance. Lie upon the ground and request your assistants to lift you, one by the legs and the other by the head, and to place you upon the chairs so that you act as a bridge between them, ankles on one seat and head and shoulders on the other. Keep your body rigid and your arms held tightly against your sides. In such a position it is now possible for somebody to sit or — if he uses the third chair as a step

and the hand of somebody else to steady himself—to stand on your unsupported mid-section without your body collapsing or giving way at all. You must simply make sure that the person does not place his weight directly upon the centre of your body, namely the pit of the stomach. If that happens you will double-up like a jack-knife.

It is all a matter of distribution of weight. Someone intending to stand should ideally place one of his feet on the centre of your chest and the other on your lower thigh. As long, as he stands or sits off-centre, however, you should experience no problem. And provided that he does not shift about unnecessarily, you should have no difficulty in retaining your rigidity. People of more than average build should in fact be able to withstand the weight of two persons of about 150 pounds, one seated on either side of the stomach.

Finally, it is worth mentioning a simple device to ensure that somebody stands where you want them to, without your having to instruct them verbally: place two handkerchiefs where his feet should go. Ostensibly, this prevents your clothes from becoming soiled. In fact, it does this and more, preventing your collapse and thus guaranteeing your safety.

Body Trick 98

During the heyday of American vaudeville, supposed Egyptian fakirs scored a great impact by combining the basic idea of the last item with the principle of inertia, which states that the greater the mass of an object, the greater the force needed to start it from rest or to stop it once it has started moving again. As the strongman reclined rigidly

between two chairs, his head and shoulders on one and ankles on the other as already described, a large heavy slab of sandstone or concrete would be placed upon his chest. That the fakir did not buckle beneath its weight is of no surprise in the context of the above. What happened next, however, appeared even more sensational.

An assistant advanced with a sledge-hammer and proceeded to strike the stone until it split into two, without the make-believe Samson appearing to suffer pain or inconvenience of any kind. Because of inertia the slab which is — and for the performer's safety must be — much larger and heavier in proportion to the sledge-hammer, moves sluggishly when struck and consequently absorbs the force of the blows which are hardly felt by the person supporting it. If the slab is too small, there is a danger that the drives of the sledge-hammer will carry through and injure the performer. The larger the slab, the easier the feat becomes. It is only necessary to ensure that the slab is not too heavy for the fakir to support. As we now know, that weight far exceeds what people not acquainted with the principles involved would imagine possible.

Hold a brick upon your outstretched hand and you will find that you can break it with a few strokes of a tack-hammer without the hand feeling any discomfort, even when it is held against a solid object for support. The same principle was at play when the Latin author, Vopiscus, wrote that Firmus, the native of Seleucia celebrated in the third century for his Herculean feats, could endure iron being forged upon an anvil placed upon his chest. The same Firmus was later executed by the Emperor Aurelian for championing the cause of Zenobia.

Body Trick 99

The preceding experiment in inertia is perfectly safe if you proceed with caution. However, for those of a squeamish disposition, who do not relish subjecting themselves to the blows of a sledge-hammer, what follows will demonstrate the effect of inertia in a more leisurely though equally amazing way. The presentation dates from ancient times when Chinese magicians performed a trick in which they appeared to cut a chopstick into two halves with nothing sharper nor stronger than the edge of a piece of paper. Unless you have a chopstick readily to hand, I suggest you use a full-length pencil. A treasury note folded sharply lengthwise down its centre to give it rigidity will suffice for the paper.

Start by asking a friend to hold the pencil very tightly by the ends in a horizontal position, with his thumbs on top and his fingers underneath. He must keep the pencil steady. You hold the folded note at one end, its long edge horizontal and your forefinger extended along it in

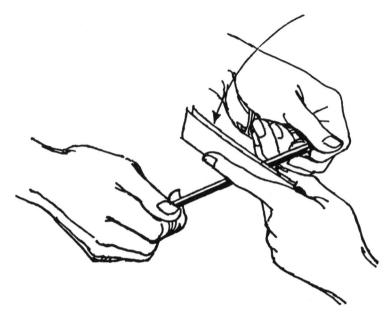

alignment. Make sure that your friend braces himself in such a way that the pencil does not fall from his fingers or give way when you strike it. The pencil will automatically break into two pieces. Bring the note and your forefinger down against it with as much force as possible and a determination to follow the blow through. Remember that your downward stroke must be sharp and strong, and must hit squarely in the middle of the pencil. Don't hesitate or be afraid. Just go ahead and you will feel no more pain than if the pencil were made of cheese.

When the Chinese originally presented the feat, they made a secret of the involvement of the forefinger in the working. For our purposes, however, it is the part played by the forefinger and the strength which it suddenly appears to possess that make the feat quite startling both to observe and to perform. What happens is that the resistance of your friend's hands imparts to the pencil the inertia needed for it first to stay put and then to snap in its reluctance to move.

Body Trick 100

If the karate-like aspect of the previous item appealed, you might wish to attempt the following. Stick the point of an ordinary pin securely into an old table-top or working surface, leaving the major part of the pin extending upright into the air. Few people would now have the courage to give the pin a smart blow with the exposed palm of the hand. And yet this is what you do, causing the pin to bend into two while leaving your hand intact.

Your attempt at derring-do works due to the combination of inertia and the preliminary precaution you take of bringing your palm down flat with one hard, forceful blow against the working surface, by way of demonstration, seconds before you slap it down for real against the pin. This momentarily hardens the surface of the palm as extra protection, by driving the blood from the surface and stretching the skin tightly. When you bring the hand down the second time you will feel little more than at your first attempt. The pin crumples before it can cause any injury to your hand.

Body Trick 101

Inertia allows even the weakest person to demonstrate that, like the self-styled Georgia Magnet and Georgia Wonder, he or she is apparently stronger than the combined force of virtually an infinite number of people.

Face a wall and, with your arms fully outstretched, place your palms flat against it, your fingertips pointing upwards. Then request, say, ten people to stand in single file behind you with their hands outstretched and touching the back or shoulders of the person immediately in front of them. On your command they must all push as hard as they can with the intention of pinning you to the wall. Their efforts to crumple you, however, will fail utterly, often throwing the line itself off balance. As long as you are able to brace yourself against the individual pressure of the person immediately behind you, their combined exertions are bound to come to nought. Because of inertia, each person absorbs the pressure of the one behind him in the chain. No one, in fact, can transmit a greater force than that which he can exert himself.

Don't worry if you are of slight stature. Just make sure that you can cope with the man immediately behind you. If you can, you should be able to resist any number of the strongest of men lined up behind him. Also, whatever your size, make sure that you resist his pressure entirely with your wrists. If you try to resist with your hands only, there is a danger of their being bent back and the wrists themselves being strained.

Body Trick 102

Another effect, whereby the individual seemingly overcomes the combined strengths of several people more powerful than himself, depends upon the principle of the pulley-block.

Ask four strong men to arrange themselves in two pairs facing each other. In addition, you require two broomsticks and a long length of rope. Each pair must grasp the end of a broomstick horizontally at arms' length so that the two sticks are parallel, as in the illustration. With the

men about three to four feet apart, you now tie one end of the rope securely to the end of one of the broomsticks and wind it zig-zag fashion around the handles five or six times, making sure that it does not cross itself at any point. You now challenge the four men to resist you, tug-of-war fashion, by pulling the brooms apart while you pull on the free end of the rope with all your might. No exertion on their part can prevent you from pulling them and the broomsticks together.

You have, in effect, created a pulley, the pressure you exert on your

end of the rope producing an attracting pull between the broomsticks, the force of which relates directly to the number of times the rope crosses between them. If, for example, you have wound the rope around the broomsticks six complete times, making twelve separate strands between them, the force you exert, when you pull on your end, is automatically multiplied twelve times, more than sufficient to overcome your opposition no matter how hard it struggles and strains.

Body Trick 103

Some of the situations in which genuine strength proves to be of no avail are quite remarkable. Find the strongest man and the frailest girl you know. Tell the girl to place the tips of her forefingers together, keeping her elbows on a level with her shoulders and to resist any attempt made to separate them. Then challenge the man to separate her fingers with a steady pull as he grasps her wrists. Jerking is not allowed and he must stand face to face with the girl. Under such conditions, unless he is King Kong or she abnormally weak, the feat is impossible because of the great strength of the chest muscles.

Other positions the girl might adopt with similar effect involve clamping a hand on her forehead or the top of her head. To remove either by exerting pressure on the wrist requires far more than average strength on the part of the other participant. In trying to force the wrist away, it is impossible to avoid an upward movement. Since the wrist and arm are attached to the shoulder, the man is at a total disadvantage, his task amounting virtually to lifting the entire body. Even if he were strong enough to lift the girl by her arm, the upward movement would still throw him completely off balance.

Body Trick 104

A not dissimilar experiment involves asking the stronger of two individuals to place his clenched fists one on top of the other and then challenging him to keep them tight together while the weaker one, preferably a girl, strikes them sharply with her forefingers. Provided that she strikes both in a horizontal plane in opposite directions at the same time, applying each finger to the corresponding fist of her opponent, namely the right finger to his right fist and likewise left to left, his fists will fly apart instantly.

The secret rests in the fact that muscles cannot act in two directions at once. While the man concentrates on exerting pressure upwards and downwards to keep his fists tight together, they will obviously be at the mercy of any pressure applied from side to side.

Body Trick 105

If you upset the centre of gravity of any object – namely the point at which the surrounding weight is exactly balanced on all sides – that object will automatically lose its balance. The same applies to the human body. Moreover, the positions in which this can happen are varied and often surprising.

Stand with one side pressed tight against the wall, your inner foot touching the skirting board about six to eight inches away from the other foot. Now, without moving away from the wall, try to raise your outside leg. It is impossible to do so without upsetting your centre of gravity and staggering all over the place. Any attempt to lift one leg means that your weight must be shifted entirely to the other if your balance is to be maintained. In the process the shoulder on the same side as the foot still on the ground leans outward to counterbalance the foot off the ground. In the position adopted here this is prevented by the wall, forcing the other foot to continue to support some of the weight of the body and preventing it from being raised without your tottering.

It is possible to manoeuvre a person into a similar predicament without going near a wall. He must stand perfectly erect, his head tilted to one side, right or left, while you hold his hip steady on the opposite side. Now tell him to keep his body still and at the same time to move his leg on the side to which his head is tilted. He will have

great difficulty in doing so. In the absence of a wall, you have contrived a situation where the weight of his entire body is now on that very leg, making it virtually impossible to lift. Your holding his hip prevents him from moving it outward, thus shifting the weight to his advantage.

For a third variation you require a chair. Place the back of the chair against the wall and, facing it, stand as far away from the chair as the chair is wide. You must now stoop down, grasp the seat of the chair with a hand at each side, and lift up the chair. Unless you are very tall, your extra height thus giving you increased manoeuvrability, this is where you lose your balance again. As long as the vertical line through your centre of gravity – a point within the body near the spine, about twenty centimetres above the navel – goes through your feet, you should have no difficulty in staying steady. Lean too far forward, however, and the vertical line itself moves forward until it is no longer over your base. You have no option but to flounder.

Body Trick 106

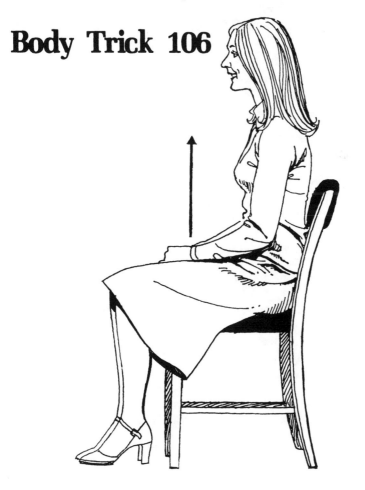

Retain the chair from the previous experiment and sit on it with your back straight, your calves vertical and your feet flat on the ground in front of you. In this position try to stand up without bending forward or moving your feet beneath the chair. Simple as the challenge sounds, it is impossible to stand under these conditions.

When you sit down, you shift the vertical line that passes through your centre of gravity away from the usual base of your feet to a point over the seat of the chair. Only when this line is perpendicular to a spot within the area of contact between the feet and the ground, is it possible to stand without toppling. This is why it is more difficult to stand on only one leg and even harder to balance on a tightrope, where so little of the foot makes contact with the surface beneath it. The only way to bring the line back within this area from a sitting position is by fulfilling one of the actions forbidden in the challenge, namely leaning forward or tucking your feet beneath the seat. Bending forward shifts the centre of gravity over the base, while shifting your feet under the chair moves the base itself beneath the centre. In real life, of course, you perform a combination of both, without giving much thought to either.

Body Trick 107

A favourite challenge of Lulu Hurst, the "Georgia Wonder", involved standing erect with a broom or billiard cue held at chest height and defying anyone to push her off balance by exerting pressure on it. Provided that one abides by certain conditions, it is not difficult to duplicate the feat, which depends upon force deflection, a principle seen at play whenever one attempts to lift an old-fashioned sash-window at arm's length. This proves virtually impossible because most of your energy is deflected in the wrong direction. Move nearer, however, and it becomes easy to raise the window, your force now being exerted upwards in the right direction.

You must stand perfectly straight, holding the broom in a horizontal position in front of your body, your hands palms downwards against the handle, about twelve to eighteen inches apart. Your elbows should be bent almost at right angles, leaving the forearms parallel. Challenge the strongest looking person you can find to stand directly in front of you and, by grasping the broom with both his hands outside your hands, to push his entire weight against it. The only stipulation you make is that he should exert a slow, steady pressure in a horizontal direction. Rushing tactics are out. Any sudden, jerky action would annihilate the principle.

However much he braces himself against the floor, your opponent

will prove unable to throw you off balance. When he begins to push out at right angles to his body, you immediately thwart those efforts by pushing in a slightly upward direction, just sufficient to keep the broom in position. This slight pressure of your own deflects his far

greater efforts clear of yourself and into space, in much the same way that a bullet or a stone travelling at high speed rebounds from water or thin ice if it strikes the surface at the appropriate angle. It is all your opponent can do to keep the broom at the level of his shoulders.

Follow these instructions and you will soon acquire the knack. When you have it mastered, you will find it no more difficult to stand upon only one foot and make the same challenge, defiantly confident that you still cannot be hurled backwards to the floor.

Body Trick 108

The principle employed in the previous test was used by the "Georgia Wonder" in another display of supposed magnetic power in which a man holding a billiard cue in a vertical position attempted with both hands to push it down towards the floor while she merely rested a palm against it. Needless to say his efforts to do so were to no avail.

Make sure that the assistant you use holds the cue vertically with

one hand at each end and his arms outstretched. To prove that you possess seemingly magnetic powers, you must place your palm against the cue at some point between the assistant's hands on the side nearest him. You do not actually grasp the cue. Merely exert enough pressure with your palm to keep it in firm contact with the cue. This deflects the force which he applies downwards in a direction at right angles to the cue and yourself. However strenuously he attempts to force the object towards the floor, all his energy is dissipated and he must keep changing the position of his body and feet to obtain what he thinks is the correct purchase, all the while in danger of losing his own balance.

Body Trick 109

However many people actually press downwards against the floor upon the end of a billiard cue or broomstick, it is possible to lift or at least dislodge it if you know the secret. Persuade at least six strong men, each using both hands, to grasp the top of a billiard cue together and to press down against it vertically with all their might. Their object is to prevent you from moving it at all. To make your challenge appear even more impressive, ask a seventh person to sit upon the seat improvised by their hands on top of the cue. This is not as difficult as it sounds if he uses a chair to climb to the top.

To accomplish the impossible, you now crawl in under the arms of those holding down the cue. To raise it off the ground, first note the direction – however slight – in which it inclines and then simply pull the end against the floor in the opposite direction to that in which the top is pointing. The cue should move without difficulty. At this point the hands exerting pressure on the top, buckle under the weight of the person sitting on them, now deprived of the cue that was taking this strain. This enables you to raise the cue high in the air almost instantaneously.

Because of the number of people crowding around the cue, it is impossible for any one of them to exert their full force upon it. Consequently the only pressure brought to bear is the mere weight of arms resting upon the top, which, even with the additional weight of the person seated above, is not enough to keep the cue pinned against the floor. Moreover, it is also worth remembering that the longer the cue or the broomstick, the less vertical pressure it is possible for the arms holding it down to exert.

Body Trick 110

Here is another opportunity to acquire a reputation for being stronger than you actually are. Three men sit on one chair and, in spite of their combined strength, you lift them. Everything depends upon how the chair, which should have a high back, is packed. It does not matter how heavy the people who sit on it are, as long as they are balanced properly.

The first person must sit naturally on the chair with his feet firmly on the floor, his hands gripping the seat of the chair at either side, and his weight thrown back against the rear of the chair causing its front two legs to tilt upwards. The second man straddles the first man's thighs, facing him, but making sure that his feet do not come into contact with the floor. The third man then sits piggy-back fashion upon the shoulders of the second, facing in the same direction.

The key to your supposed display of strength is the leverage provided by the feet of the first man, which must stay planted firmly upon the ground. With your palms flat against the top of the chair-back simply push forward, without attempting to lift anything. This shifts the total weight of men and chairs from the fulcrum residing in the rear legs of the chair to a new fulcrum point within the first man's feet. It just so happens that the amount of pressure required to shift the fulcrum forward is minimal by comparison with the combined weight of three men and one chair, which you appear to lift six inches or more into the air, leaving nothing touching the floor but the two feet which go unnoticed.

Body Trick 111

The *pièce de résistance* of the Georgia miracle ladies was their ability to withstand the attempts of anyone to lift them from the ground.

The person challenged to try the feat must stand facing the performer, who holds his or her elbows tightly against the sides of the body with the hands pointed towards the shoulders. The only stipulation is that the spectator lifts you by the elbows, one hand under each. As long as your elbows are pointing straight towards the ground, along the perpendicular that drops from your centre of gravity, this should not prove difficult. Any upward pressure applied to the elbows works directly against the attraction of gravity, lifting you into the air accordingly.

However, if slightly and imperceptibly you shift your elbows forward, you move your centre of gravity backwards, making it now impossible for the body to be balanced at the elbows since they are

no longer in line with the perpendicular passing through your centre of gravity. This is why only a veritable Samson would be able to lift you by the elbows in this position. Moreover, the more flexible and loose from the shoulders you keep your arms, the more difficult it becomes.

Body Trick 112

The history of the occult contains many claims by allegedly super-human individuals to powers of levitation, the total opposite in many ways to the seeming skills displayed in the preceding experiment. It is unlikely, however, that much has been achieved by way of weight-lessness other than the delusion of floating gained from the breathing and relaxation exercises chiefly prescribed in this context. Recent claims by Maharishi Mahesh Yogi and his disciples of transcendental meditation that they can fly have produced nothing more concrete by way of evidence than an assortment of photographs, which would be more convincing if one could be given the assurance that a tram-poline was not discreetly out of camera range at the bottom edge of the frame. Needless to say, not one of these self-propelled aeronauts has yet claimed the £10,000 challenge made in the British national press by the distinguished British magician, David Berglas, in the summer of 1977. In lieu of instructions to achieve the genuine phenomenon, one submits the following by way of compromise. If these directions are followed with care, it is possible for the heaviest person to appear to achieve weightlessness to the extent that he or she can be raised into the air on no more than the index fingers of four far smaller people.

The person who is going to float must sit relaxed in a straight-backed chair with his legs together, his feet on the floor, and his hands in his lap. The other four participants now stand two on each side of the seated party, one at each shoulder and one at each knee. Instruct all four to extend their arms and place their closed fists together, closed except for the forefingers which should be extended and touch-ing each other along their lengths as shown. The person nearest the seated man's left shoulder is now asked to place his two extended fingers, palms downwards, beneath his left armpit. Likewise, his opposite number inserts his forefingers beneath the right armpit, and again the other two respectively beneath the seated man's knees. Now invite the four assistants to lift the man in this position, using only these extended fingers. However hard they try, it is impossible. As soon as you have registered their inability to do so, ask them to stack their hands alternately, one on top of the other on the man's head, in such a way that no person has his own two hands together, and then to exert a steady pressure downwards. As they keep this up you count to ten. On the count "nine", they must withdraw their hands quickly from his head and resume their earlier positions with their extended forefingers. On the count of "ten" they must try again to lift the man with those fingers alone. This time he will go soaring several feet into the air with no difficulty whatsoever.

No one has yet produced a satisfactory answer as to why this should work. If on the first attempt at lifting you explain how difficult it is to raise the seated man under the conditions given and then the second time around underline the ease with which it can be done, then obviously the power of suggestion can play a positive part. However, this cannot be the whole explanation.

At the first attempt the lack of coordination amongst the assistants does not help their cause. Conversely, the second time around, your own count of ten as well as their past experience of what they have to do, ensure a concerted effort which helps to make the lift easier for everyone involved.

During the early months of 1960 this feat was the subject of much discussion in *Abracadabra*, an exclusive weekly magazine published in Britain for magicians. Making more sense than most of those who contributed their pet theories, was one Dr. McF. McKee who pointed out that:

The muscles surrounding the joints of the body can be divided into two groups, one working against the other. In any movement of the joint, the muscles activating the movement have to overcome those which would create the opposite movement. Just before making the levitation, the experimenters press down on the subject's head, tiring one set of muscles so that the lifting muscles which perform the opposite action a few moments later have less resistance to overcome.

From the point of view of the seated party, he at first has no sense of balance in the strange situation in which you place him and will most probably flounder in all directions. When subjected to the combined pressure on his head, however, he will naturally brace himself and exert a vertical pressure to resist. Provided, therefore, that he is lifted quickly after the hand pressure is released, he is physically prepared to soar to the ceiling without losing his balance.

Body Trick 113

The contribution which the suggestibility of the participants can make to the smooth running of the previous experience, finds a parallel in the following experiment cited by Robert E. Ornstein in his book *The Psychology of Consciousness*. It derives from the Japanese discipline of Aikido and related martial arts dependent upon the subtle direction of "energy flow" for their effect.

First ask a friend to lift you off the ground three times in succession with a few seconds' rest between lifts. The first time, you do or think nothing out of the ordinary. The second time, without telling him,

you think "up" and actually imagine your body soaring through the air on wings or being hauled up to the heavens on an invisible wire. The third time you think "down" and concentrate hard on the idea of being weighted or tied to the floor, as though your legs are an actual extension of the earth. With each lift your friend should be able to feel the results of your thought projection, being able to lift you more easily when your thoughts are directed skywards, and with greater difficulty when they are directed to the earth.

Eventually explain the procedure to him and suggest that you reverse rôles. You will lift *him* three times but he must mix up the three thought processes – "neutral", "up" and "down" – in any order he chooses without telling you. Provided that he does concentrate hard, it is a surprisingly easy matter for you to divine the correct sequence.

Body Trick 114

It seemed appropriate, in a section where the heaviest person has been made to appear weightless and the frailest far stronger, to include the inner secret of the demonstration we have all seen at fairgrounds, where the carnival pitchman attempts to guess your weight within three pounds and invariably wins. I had always assumed that he owed his unfailing accuracy to a device called inscrutably by magicians a Swami gimmick, an exact description of which it would be unethical to give here, but which has been used by them and by bogus spirit mediums for ages to write information secretly on a slate or a piece of paper after it has been obtained and while the audience's attention is sufficiently misdirected. Then, while reading an obscure pamphlet, *Unik Trix that Klix*, written and published between the wars by the American magician Nelmar, I discovered the formula that follows. The fact that one immediately tried it out on oneself and met with instant success qualifies its inclusion by way of a coda and diversion here.

The first thing to estimate is the height of the person whose weight you are going to guess. Have the individual stand immediately in front of you with arms at the sides and looking straight ahead. Stand alongside and you will find that, provided you know your own height, it is an easy matter to guess how tall somebody else is by comparison. You must then feel the person's arm muscles and decide which description they best fit: "thin", "fat" or "medium". Armed with this information, you have only to consult the following table to find how many pounds your victim weighs. Obviously, if you really intend to impress with this demonstration, you should commit the table to memory.

MALE

FT.	IN.	THIN. POUNDS	MED. POUNDS	FAT. POUNDS
5	00	95	110	128
5	1	100	118	138
5	2	110	124	150
5	3	113	130	156
5	4	115	135	159
5	5	117	139	162
5	6	119	140	164
5	7	123	145	167
5	8	127	149	169
5	9	130	154	172
5	10	135	158	174
5	11	140	164	176
6	00	145	167	180
6	1	149	172	183
6	2	154	176	186
6	3	160	180	187
6	4	163	185	190

FEMALE

FT.	IN.	THIN. POUNDS	MED. POUNDS	FAT. POUNDS
4	8	75	81	100
4	9	80	100	120
4	10	94	115	138
4	11	100	122	144
5	00	102	126	149
5	1	105	129	156
5	2	108	131	160
5	3	112	133	162
5	4	115	136	163
5	5	117	139	165
5	6	120	142	167
5	7	125	146	170
5	8	130	149	174
5	9	138	154	177
5	10	141	157	179
5	11	144	161	182
6	00	147	165	185

14 Finale

The intention of *Body Magic* has been to catalogue as comprehensively as possible those seemingly magical phenomena that emanate from within the human biological system. And yet, however miraculous the human anatomy may be, it is a mere cipher without an environment in which to function and with which to interact. The celebrated physiologist, Moshe Feldenkrais, has painted an appropriate working picture of the human being in which the "core" of the nervous system and the "envelope" of skeleton, skin, viscera and muscles, coexist with the environment, a scenic backcloth comprising space, gravitation, the elements, and social milieu.

Many of the tests described in this volume interact in their own way with the environment in one or more of these guises. What distinguishes the next experiment is that while at one level it is no more than a superior optical illusion, the basis of which has already been described in Body Trick 24, at another its effect depends almost entirely upon an artificially created environment, simultaneously involving the whole body. We are no longer concerned with the surprising detail of just one aspect of the anatomy; no item would seem to illustrate Feldenkrais' observation more effectively. As such it provides a fitting climax for a book of surprises. The magical mystery tour begins here, and yet, as you will see, in true Wonderland fashion, you do not move an inch.

As Einstein insisted, everything is relative. Nothing could be more true of the illusion of movement achieved by the device about to be described, the brainchild of Kelly Green, the Californian magician and mystic, first described by him in *Abracadabra*. In effect a lantern, it is simply a cardboard cone, not unlike a witch's hat, with an attractive pattern cut filigree-fashion all around and a flat opaque base attached. On the base, beneath the cone, is placed a self-contained source of light. This can be either a candle-flame or a battery lamp. The whole contraption is then suspended from the ceiling by two thin cords, no more than an inch apart, fastened to the top of the cone. Keep twirling the lantern until the strings are wound so tightly around each other that, when left to untwirl, they will for a while keep entwining themselves alternately in reverse directions under their own momentum. Finally obtain the help of a friend, who must hold the lantern steady until you give the go-ahead.

Switch off all the other lights in the room and lie down flat on your back on the floor with your head on a cushion directly beneath the lantern. Tell your friend to release the lantern. At first the filigree pattern reflected on the ceiling will appear to revolve in alternate directions. After a while, however, you will feel the strangest sensation.

The pattern on the ceiling will lose momentum, while you yourself begin to feel that you are revolving, first in one direction, then, after a pause, in the opposite one, all the time as if your head is at the hub of an imaginary wheel, your feet on its rim. The faster your accomplice

swings the lamp, the faster you will appear to whirl around. Moreover, when eventually the lantern slows down of its own accord, so the changes of direction will appear more frequent, until it comes to a standstill. Experimentation will determine the best length of the two strings and the distance between them, depending upon the weight of the lantern.

Bibliography

Abbott, David Phelps, *Behind the Scenes with the Mediums*, Chicago, Open Court, 1907

Anderson, George B., *Magic Digest*, Northfield, Illinois, Digest Books Inc., 1972

Annemann, Theodore (editor), *The Jinx* (three volumes), New York, Louis Tannen, 1963–4

Asimov, Isaac, *The Human Body*, Boston, Houghton Mifflin, 1963

Boring, Edwin G., "The Moon Illusion", *American Journal of Physics*, April 1943

Bragg, Sir William, *The Universe of Light*, New York, Dover, 1959

Brewster, Sir David, *Letters on Natural Magic*, London, John Murray, 1832

Brindley, G. S., "Afterimages", *Scientific American*, October 1963

Bruner, Jerome and C. C. Goodman, "Value and Need as Organising Factors in Perception", *Journal of Abnormal and Social Psychology*, 42, 1947

– and Leo Postman, "On the Perception of Incongruity: a Paradigm", *Journal of Personality*, 18, 1949

Christopher, Milbourne, *Seers, Psychics and E.S.P.*, London, Cassell, 1971

–, *Mediums, Mystics and the Occult*, New York, Thomas Y. Crowell, 1975

Conway, David, *Magic: An Occult Primer*, London, Cape, 1972

Corballis, Michael C. and Ivan L. Beale, "On Telling Left from Right", *Scientific American*, March 1971

Corinda, *13 Steps to Mentalism*, London, Corinda's Magic Studio, 1958

Cremer Jnr., W. H. (editor), *The Secret's Out*, London, Chatto & Windus, *c.* 1871

–, *The Magician's Own Book*, Edinburgh, John Grant, 1871

–, *Magic no Mystery*, Edinburgh, John Grant, 1876

Cumberland, Stuart, *A Thought-Reader's Thoughts*, London, Sampson Low & Co., 1888

Dawson, Peter, *The Brain Game*, London, Valldaro Books, 1976

De Bono, Edward, *The Use of Lateral Thinking*, London, Cape, 1967

–, *The Five-Day Course in Thinking*, London, Cape, 1968

–, *The Mechanism of Mind*, London, Cape, 1969

–, *Practical Thinking*, London, Cape, 1971

151

Deutsch, Diana, "An Auditory Illusion", *Nature*, September 27th, 1974
—, "Musical Illusions", *Scientific American*, October 1975
Dexter, S. Eddie, *Entertaining with Contact Mind-Reading*, Enfield, Middlesex, Magic Wand, 1952
Dillard, Annie, *Pilgrim at Tinker Creek*, London, Cape, 1975

Eccles, J. C., *The Neurophysiological Basis of Mind*, Oxford, Clarendon Press, 1953

Fischer, Ottokar, *Illustrated Magic*, New York, Macmillan, 1931

Gardner, Martin, *The Ambidextrous Universe*, New York, Basic Books Inc., 1964
—, *Science Puzzlers*, London, Macmillan, 1962
Gazzaniga, Michael S., "The Split Brain in Man", *Scientific American*, August 1967
Gerard, Ralph W., "What is Memory?", *Scientific American*, September 1953
Gibson, Walter B., *The Book of Secrets*, Scranton, PA, Personal Arts Co., 1927
—, *The Key to Hypnotism*, New York, Key, 1956
—, *Magic with Science*, London, Collins, 1970
Gregory, Richard L., *Eye and Brain*, London, Weidenfeld and Nicolson, 1966
—, *The Intelligent Eye*, London, Weidenfeld and Nicolson, 1970
—and E. H. Gombrich (editors), *Illusion in Nature and Art*, London, Duckworth, 1973

Haagen-Smit, A. J., "Smell and Taste", *Scientific American*, March 1952
Harbin, Robert, *Party Lines*, London, Oldbourne, 1963
Heriot, John, *Teaching Yourself White Magic*, Newton Abbot, Devon, David & Charles, 1973
Hess, Eckhard H. and James M. Polt, "Pupil Size as Related to Interest Value of Visual Stimuli", *Science*, August 5th, 1960
—, "Pupil Size in Relation to Mental Activity during Simple Problem Solving", *Science*, March 13th, 1964
—, "Attitude and Pupil Size", *Scientific American*, April 1965
—, "The Role of Pupil Size in Communication", *Scientific American*, November 1975
Hilgard, Ernest R., Richard C. Atkinson, and Rita L. Atkinson, *Introduction to Psychology*, New York, Harcourt Brace Jovanovich, 1953
Hoffmann, Professor Louis (Angelo Lewis), *Magic at Home*, London, Cassell, 1891

Hopkins, Albert A. (compiler and editor), *Magic: Stage Illusions and Scientific Diversions*, London, Sampson Low, Marston & Co., 1897
Houdini, Harry (editor), *Elliott's Last Legacy*, New York, Adams Press Print, 1923

Index of Possibilities: Energy and Power, An, London, Wildwood House, 1974

James, William, *The Principles of Psychology* (2 volumes), New York, Dover, 1950

Karson, J., *Hypno Tricks*, Springfield, Mass., Karson Exclusives, 1940
Kaufman, Lloyd and Irvin Rock, "The Moon Illusion", *Scientific American*, July 1962
Kolers, Paul A., "Apparent Movement of a Necker Cube", *American Journal of Psychology*, June 1964
—, "The Illusion of Movement", *Scientific American*, October 1964
Kreskin, *The Amazing World of Kreskin*, New York, Random House, 1973

Lippold, Olof, "Physiological Tremor", *Scientific American*, March 1971
Lorayne, Harry, *Secrets of Mind Power*, New York, Frederick Fell, 1961
— and Jerry Lucas, *The Memory Book*, New York, Stein and Day, 1974
—, *Remembering People*, New York, Stein and Day, 1975
Luckiesh, M., *Visual Illusions*, New York, Dover, 1965
Luria, A. R., *The Mind of a Mnemonist*, London, Cape, 1969

McConnell, James V., *Understanding Human Behaviour*, New York, Holt, Rinehart & Winston, 1974
McGill, Ormond, *The Encyclopaedia of Genuine Stage Hypnotism*, Colon, Michigan, Abbotts, 1947
—, *Psychic Magic* (6 volumes), Colon, Michigan, Abbotts, n.d.
—, *How to Produce Miracles*, New York, A. S. Barnes, 1976
Madsen, Bill (editor), *Hex!*, Boston, New Jinx, 1969
Maly, Charles J., *Celestial Agent*, Chicago, Ireland, 1944
Marcuse, F. L., *Hypnosis: Fact and Fiction*, Harmondsworth, Pelican, 1959
Maurois, André, *Illusions*, New York, Columbia University Press, 1968
Miller, Hugh, *Hypnotism*, London, Unique Magic Studio, n.d.
Minnaert, M., *The Nature of Light and Colour in the Open Air*, New York, Dover, 1954
Mulholland, John, *Book of Magic*, New York, Charles Scribner's Sons, 1963
—, *Magic of the World*, New York, Charles Scribner's Sons, 1965

Nelmar, *20 Hypnotic Tricks*, Chicago, Nelmar System, 1933
—, *Unik Trix that Klix*, Chicago, Nelmar System, n.d.
Nelson, Robert A., *Hellstromism*, Columbus, Ohio, Nelson Enterprises, 1935
—, *Hypno-Trix*, Calgary, Alberta, Hades, 1974

Ornstein, Robert E., *The Psychology of Consciousness*, New York, Viking Press, 1972

Panati, Charles, *Supersenses*, London, Cape, 1975
Pearsall, Ronald, *The Table-Rappers*, London, Michael Joseph, 1972
Penfield, W. and L. Roberts, *Speech and Brain Mechanisms*, Princeton, N.J., Princeton University Press, 1959
Perelman Ya., *Physics for Entertainment* (2 volumes), Moscow, Mir Publishers, 1975

Ratcliff, J. D., *The Body and How it Works*, London, Hodder and Stoughton, 1976
Rawcliffe, D. H., *Illusions and Delusions of the Supernatural and the Occult*, New York, Dover, 1959
Rock, Irvin, *The Nature of Perceptual Adaptation*, New York, Basic Books Inc., 1966
—and Charles S. Harris, "Vision and Touch", *Scientific American*, May 1967
Rosenzweig, Mark R., "Auditory Localization", *Scientific American*, October 1961

Scarne, John, *Scarne's Magic Tricks*, London, Constable, 1953
Schatz, Dr. Edward R., *Practical Contact Mind Reading*, Calgary, Alberta, Hades, 1974
Smith, Anthony, *The Body*, London, George Allen and Unwin, 1968

Tom Tit, *Scientific Amusements* (translated from the French by Cargill G. Knott), London, Thomas Nelson, 1918

Vernon, M. D., *The Psychology of Perception*, Harmondsworth, Pelican, 1962
Von Békésy, Georg, "The Ear", *Scientific American*, August 1957
Von Helmhotz, H., *Physiological Optics*, New York, Dover, 1962

Walker, Jearl, *The Flying Circus of Physics*, New York, Wiley, 1975
Warren, Richard M., "Perceptual Restoration of Missing Speech Sounds", *Science*, January 23rd, 1970
—and Roslyn P. Warren, "Auditory Illusions and Confusions", *Scientific American*, December 1970

Waters, T. A., *Psychologistics*, New York, Random House, 1971
Watson, Lyall, *Supernature*, London, Hodder and Stoughton, 1973
—, *The Romeo Error*, London, Hodder and Stoughton, 1974
—, *Gifts of Unknown Things*, London, Hodder and Stoughton, 1976
Weatherly, Lionel A. and J. N. Maskelyne, *The Supernatural?*, Bristol,
 Arrowsmith, 1891
Willane, *Willane's Wizardry*, London, Arcas, 1947
Wilson, Colin, *The Occult*, London, Hodder and Stoughton, 1971
—, *They Had Strange Powers*, London, Aldus, 1975
—, *Enigmas and Mysteries*, London, Aldus, 1976
—, *The Geller Phenomenon*, London, Aldus, 1976
Wittreich, Warren J., "Visual Perception and Personality", *Scientific
 American*, April 1959
Wood, A., *The Physics of Music*, London, Methuen, 1962

Guide To Body Tricks

	Body Trick Numbers
After-image	11, 23
Ambidexterity	6
Balance	3, 50, 89, 105, 107
Blind Spot	9
Blood	91–96, 100
Bone conduction	25
Brain	1–6, 12, 13, 14, 17, 30, and *passim*
Centre of gravity	105, 106, 111
Cerebral hemispheres	3, 6
Colour	22, 23
Conditioned response	4, 5, 13, 17, 28
Coordination	2, 3, 6, 18, 47, 55, 56, 85
Environment	13, 14, 24, 30, 65, 78, 79, 90, finale
Eyes	87 (and see Vision)
Fingers	52, 53, 58, 76, 84, 85
Hand	2, 3, 6, 19, 20, 45, 46, 47, 49, 52–58, 75, 76, 84, 85
Handedness	3, 6
Hearing	25–34
Hearing, Binaural	29, 34
Ideomotor impulse	65–74, 75–79, 113
Inertia	98, 99, 100, 101
Irradiation	16
Itching	80
Leverage	52, 102, 107, 108, 109, 110
Levitation	112
Lifting	110, 111, 112, 113
Memory	59–64
Muscles	52, 53, 54, 97, 98, 101–114
Phosphene	7
Pulse	92, 93, 94
Pupils	1, 24
Retina	8, 9, 10, 11, 12, 15, 16
Size distortion	13, 14, 39, 40, 50
Skin	95, 96, 100 (and see Touch)
Smell	36–38, 81
Speech	3, 30, 31, 32, 33
Suggestion	28, 37, 38, 43, 48, 49, 80–90
Taste	35–38, 82
Teeth	25

Temperature	41, 42, 43, 44
Thumb	54, 95
Touch	3, 17, 28, 39–51
Vision	7–24, 50, 51, 58, finale
Vision, Binocular	18, 19, 20, 21
Vision, Retention of	10, 11, 23
Weight	17, 41, 114
Weight, Distribution of	97, 98